Practical Calligraphy

Practical Calligraphy

JOHN NASH

AND

GERALD FLEUSS

HAMLYN

This book
is dedicated to
ANN CAMP
craftsman and teacher

The authors wish to acknowledge the contribution of Patricia Gidney
in writing the exemplars on pages 90-99 and in drawing many
of the items in the chapter on Heraldry. They also wish to thank
Frank Bird L.B.I.P.P. for his photographic work.

Published by
The Hamlyn Publishing Group Ltd
part of Reed International Books
Michelin House, 81 Fulham Road
London SW3 6RB

ISBN 0 600 57177 7

Produced by Mandarin Offset Printers in Hong Kong

CONTENTS

INTRODUCTION

THIS is a workbook. It will not make you into a creative genius overnight or lead you to financial wealth in your spare time. Our intention is to present you with basic models of scripts which have proved most useful to the modern letterer, stripped to their essentials and as free as possible of mannerisms, providing you with a foundation on which to build.

The design of the book is such that with 'B' pencils (not too soft, not too hard) and a 3 mm broad-edged nib, you can begin, if you wish, by laying a sheet of transparent or semi-transparent paper over the page and working directly from it, first acquainting yourself with the skeleton form of the letter, then the double pencil or 'X-ray' form, then the pen-made form. You should start as soon as possible to put the letters together into words and phrases, making use of the information in the 'Spacing and Layout' chapter. Use the letters, do not merely practise them. When uncertainty strikes, go back to the models and refresh your memory. Do not add ornamental peculiarities for their own sake. As you become more skilful your writing will naturally take on an individual quality which should never be forced.

A word may be said here about the importance of the work of Edward Johnston, who virtually rediscovered the craft of calligraphy at the turn of the century. His contribution has in recent times been widely misunderstood, even by scholarly writers, and it has become fashionable in some quarters to denounce what has come to be referred to as the Johnston tradition, as though it represents some outmoded 'style'. Johnston's perceptive insight included the grasp of the value

of the broad-edged pen as *the* educative letter-making tool which would, if one allowed it, unlock the secret of the structure and shape of letterforms. From his studies in the British Museum, and with the help and advice of Sydney Cockerell, he chose a clear 10th century English Caroline script which led to the development of his 'Foundational Hand', the kernel of his teaching method. In this single script, as he wrote to Paul Standard in 1944, he recognized 'the perfected Seed of our Common Print'. He had therefore discovered a script capable of great development once harmonious modern features were substituted for archaic ones. "One may lawfully follow a *method* without imitating a style," he said. Once this has been grasped by the student, endless opportunities arise for the development of truly personal interpretations of letterforms.

As its name implies, this book is intended for the use, not only of would-be calligraphers, but of letter-carvers, sign-writers, graphic designers – all those who use letters. Pen lettering and calligraphy should not be thought of exclusively in connection with the presentation address and the manu-script book, still less the currently fashionable 'alphabet soups' – those bowlfuls of self-expression in which letters are to be dimly seen here and there, both waving *and* drowning. The learning of lettering and calligraphy, like any self-respecting craft, is not a matter of blinding inspiration but of hard work and careful thought. The lettering world today is overburdened with those who have only a superficial know-ledge of the forms and history of letters. We hope this book may go some way toward redressing the balance.

A BRIEF HISTORY OF CALLIGRAPHY

THE development of our Roman alphabet when viewed against man's long evolutionary process – the earliest known hominids appeared over a million years ago and homo sapiens (modern man) some 10,000 years ago – is something of a last-minute aberration. The earliest needs of social interaction led to various forms of primitive pictography (see Fig. 1) and ideography, but it is generally agreed that it was the Phoenicians who sowed the seeds of an alphabetic means of communication, in which the symbols represented primary oral sounds. The Phoenicians were a gifted Semitic race living on the seaboard of what is roughly the modern state of Lebanon. Their origins are extremely obscure but there is certain evidence of their existence in the third millennium B.C. The sea was their livelihood and an important trade with Egypt was developed, leading later to the settlement of craftsmen there and their adoption of Egyptian art forms. It seems probable that the Phoenician alphabet arose in about the 15th century B.C. and had spread to Greece and Etruria by the 8th or 7th century.

The original method of writing was from right to left, superseded later by *boustrophedon* writing where alternate lines run right to left and left to right (see Fig. 2). After about 500 B.C., the regular practice was to write from left to right, top to bottom, as we know it today. The development of the Greek alphabet was always in the direction

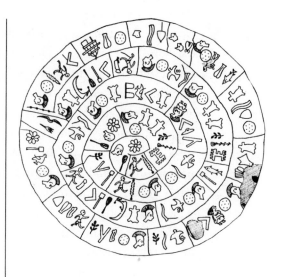

FIGURE 1. *An example of pictography, the Phaistos Disc c. 1700 B.C.*

of artistic refinement away from its early geometric forms, and a transformation of the early consonantal Semitic script into a modern alphabet with symmetry and subtlety of form.

The derivation of the Latin alphabet can be traced to all three influences – Semitic, Etruscan and Greek – and the earliest known examples are engraved forms cut in stone or metal with sharp tools (see Fig. 4 overleaf). These letters are what we would now term 'capitals'. By the 2nd century A.D. Roman inscriptional lettering had reached its zenith in terms of perfection of letterform and spacing, and the supreme example of the Roman letter-carver's art is

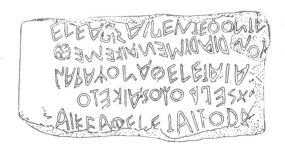

FIGURE 2. *Early Greek inscription written in the boustrophedon style – alternate lines from left to right, and right to left: literally 'ox turning' or ploughing.*

the inscription at the base of Trajan's column in Rome, which is dated 114 A.D. (see Fig. 3). It is generally held that the later inscriptional letters were often drawn out first with a broad, flat brush in paint and then cut in V-sections (see below) with a chisel, hence the underlying calligraphic influence evident in the thick and thin 'shading' of the strokes.

There is little evidence available to us concerning the transformation of the monumental capitals used for inscriptions on stone and metal into written forms made with pen and ink on papyrus and parchment. From the 1st century B.C., however, a less formal, laterally compressed capital appears, which has a counterpart in manuscript writing, the earliest example of which is the letter of a slave from around the middle of that century. This script, which employed an unusually steep angle of the pen nib to the horizontal writing line, has become known as *Capitalis Rustica* (Rustic Capitals). In its more refined form it continued as the principal book hand of the classical period until its gradual displacement by the beautifully rounded and more naturally calligraphic uncial forms beginning about the 4th century A.D. Recent evidence suggests that the uncial hand was actually in existence some considerable time before this date. Even then, it continued in use as a display script right down to the Middle Ages.

FIGURE 3. *Roman monumental lettering. The inscription from the base of Trajan's columns in Rome, 114 A.D.*

SENATVSPOPVLVSQVEROMANVS
IMPCAESARIDIVINERVAEFNERVAE
TRAIANOAVGGERM·DACICOPONTIF
MAXIMOTRIBPOT·XVIIIMPVICOSVIPP
ADDECLARANDVMQVANTAEALTITVDINIS
MONSETLOCVSTAN·····IBVSSITEGESTVS

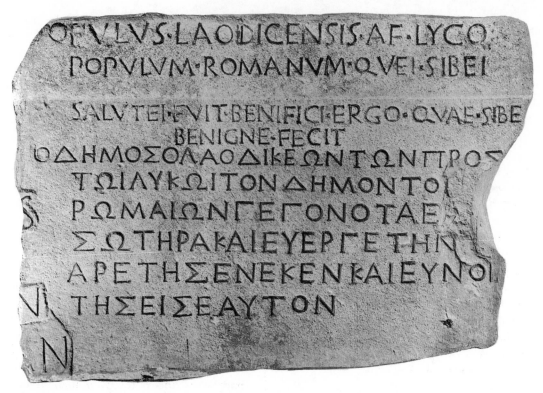

What has often been regarded as a sister script to Rustic Capitals, but in fact probably postdated it by several centuries, was *Capitalis Quadrata* (or Square Capitals). This was a pen-made imitation of the monumental inscriptional script, written on vellum, and involved a somewhat tor-

FIGURE 4. *Greek and Latin inscription of 'Populus Laodicensis' from the Quirinal, Rome, mid-1st century* B.C. *(Vatican Museum)*

FIGURE 5. *Capitalis Quadrata (Square Capitals) of the 4th century* A.D. *Virgil's* Georgics. *(Codex Augusteus, Vatican Library)*

tuous 'ductus' (hand movement) with many changes in pen-angle; it must have been very slow in execution. Rustic Capitals and Square Capitals were reserved almost exclusively for deluxe editions of the great literary works of the classical era, in particular those of Virgil. Only a few have survived as evidence; our illustrations show the 4th century Codex Augusteus (Fig. 5) in Square Capitals and a copy of the Codex Romanus (Fig. 6).

Rustic and Square Capitals were the formal hands used in the great literary works of the classical period, but that is not to say that there was not an everyday style

of writing which, in the desire for speed and economy, had become 'joined-up' or 'cursive' in character, and of course the two styles developed side by side. This cursive writing contained many variants of style.

Wax-coated wooden tablets (see Fig. 7) provided an alternative to the more expensive papyrus and parchment and the usual writing implement was the needle-like stylus. These tablets were usually fastened together by means of a thong or clasp, a

FIGURE 6. *A virgil of the 5th century A.D. in Rustic Capitals, the Codex Romanus. (Vatican Library, MS Vat. Lat. 3867)*

method which was important in the development of our present form of book, the codex. Papyrus (see Fig. 8) had been the standard writing material of antiquity; it was prepared by cutting thin strips from the fibrous pith of a tall plant of the sedge family that grew freely in the Nile delta. Two layers of these strips, one laid at right angles over the other, were pressed together to form sheets. The sheets could then be pasted together to make a roll.

Sheep and goatskin were used as substitutes when papyrus was in short supply but their surfaces were nowhere near as sympathetic to write on. It has been claimed, but not verified historically, that at some time during the Hellenistic period, the Egyptian government placed an embargo on the export of papyrus and, during the search for an alternative, a process was devised at Pergamum for treating animal skins to give a better writing surface than

FIGURE 7. *A page from a heptaptych or set of seven wax tablets.*

FIGURE 8. *Latin papyrus written in cursive script, 1st century* A.D.

the leather used hitherto. (The term parchment is said to have originated from Pergamum.) The embargo was later lifted and it was not until well into the Christian era that parchment came into common use for books. It must be said, however, that the development of parchment was more likely to have been a slow one. Certainly, the superior durability of that material, and the substitution of the awkward papyrus roll in favour of the codex between the 2nd and 4th centuries A.D., has ensured the survival of a great deal of classical literature, transferred from papyrus.

Uncial and Half-Uncial

From the Christianization of the Western part of the Roman Empire arose the need for a new script whose pedigree is probably found in the beautifully rounded and harmonious Greek Biblical Uncial script exemplified in the great 4th-century Codex Sinaiticus (see Fig. 9). Some of the characters of the Latin Uncial (see Fig. 10) are directly descended from Square Capitals but the Greek influence is to be seen in the rounded forms of 'd', 'e', 'h', 'm' and 't'. The characteristics of the Uncial hand derive from a relatively flat pen angle and few ascending and descending strokes. This

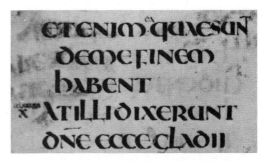

FIGURE 10. *Jerome's Latin version of the Chronicle of Eusebius. Roman uncial hand 5th/6th centuries A.D. (Bodleian Library, Oxford)*

majestic script reached its zenith in the 5th century (see Fig. 10) and remained in use even after the break-up of the Empire, indeed until the 8th century, and later (together with Rustic Capitals) as a 'display script'.

The existence of an everyday script has already been mentioned, its cursiveness a result of speed and economy; this economy also led to a simplification of capital (majuscule) forms towards minuscule or, in printers' terminology, 'lower case' (see Fig. 12). A combination of uncial and cursive is apparent in the companion script we now term half-uncial (see Fig. 13), a script which as we shall see was taken as a model

FIGURE 9. *The Codex Sinaiticus, in a Greek uncial script of the 4th century A.D. In 1933 this codex was purchased by the British Museum from the Soviet Government for £100,000.*

FIGURE 11. *English uncial ('artificial' uncial) of the 7th or 8th century A.D. This example could have been produced at Jarrow or Wearmouth. (Durham Cathedral Library)*

FIGURE 12. *Roman minuscule cursive of the 7th century A.D.*

FIGURE 14. *Visigothic minuscule script of the 8th/9th century A.D. 'Isodorus Pacensis', Chronicon (B.L. Egerton MS 1934). (By courtesy of the British Library)*

by the Irish and developed by them in a remarkable and entirely individualistic way.

Despite the spread of learning and development of new scripts the western part of the Roman Empire had been in decline since the 2nd century A.D., with economic breakdown and political chaos continuing in the 3rd century. Final collapse came with the barbarian invasions of the 6th century and the establishment of the Vandal, Visigothic, Ostrogothic, Burgundian and Frankish kingdoms with a reversion to old national cultures. The old Roman cursive hands were taken up as models for new formal scripts (see Fig. 14), thus giving 'official' recognition to minuscule writing.

Racial migration and incessant wars heralded a new era of confusion and barbarism which we now refer to as the Dark Ages and which lasted from around

550 to 750 A.D. In mainland Europe cultural life was in decline. Education and the care of books rapidly passed to the Church. Christians became hostile towards pagan classical literature, much of which was henceforth destroyed. Cassiodorus, who had had a long and successful career in the Ostrogothic civil service, foresaw the future role of monasteries as the main hope for intellectual continuity and devoted his retirement to the cause, establishing the monastery and library of Vivarium on his estates in southern Italy some time after 540 A.D. About the same time, Benedict of Nursia established a monastery at Monte Cassino and by the promulgation of his Benedictine Rule laid the foundation on which monastic life was based for many centuries. Even so, very few of the great books of antiquity survived the Dark Ages.

Insular Scripts

We now need to consider a remarkable side-culture of the Dark Ages which had a marked effect on the revival of learning in the following centuries.

Ireland was a remote outpost of Christianity, untouched by the convulsions in Europe, and was possessed of a great enthusiasm for learning and an aptitude for producing extremely fine manuscripts, a remarkable number of which appeared in

FIGURE 13. *Roman half-uncials of the 7th/8th century A.D. 'Primasius in Apocalypsin'.*

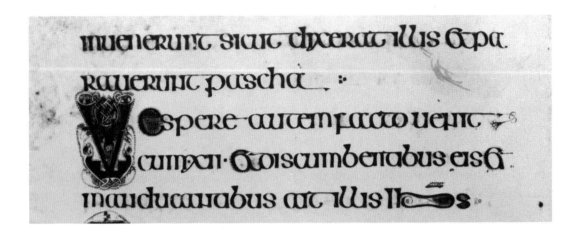

FIGURE 15. *Insular half-uncial script: the Book of Kells, c. 800 A.D. (Trinity College Library, Dublin)*

the 7th and 8th centuries. A most beautiful half-uncial script emerged, adapted from Gallic models, the culmination of which is to be seen in such great manuscripts as the Book of Kells and the Lindisfarne Gospels (see Figs. 15 & 16). The Irish were also endowed with a missionary zeal which led to the establishment of monasteries in Iona in 563 by Saint Columba, leading to the Christianization of Scotland, and at Lindisfarne and Malmesbury in England. A continental mission by Columbanus (543–615) led to the founding of the great monasteries at Luxeuil in Burgundy (590),

St. Gall in Switzerland (613) and Bobbio in Northern Italy in 614.

While the Latin culture of Ireland was percolating into northern England, Pope Gregory the Great sent Augustine to the south of England in 597 to convert the pagan Anglo-Saxons to Christianity; the new faith eventually spread throughout the country. The dual monasteries of Jarrow and Wearmouth in north-east England were founded in 674 and 682 by Benedict Biscop (see Fig. 11); a monk at the first of these, Bede, became the greatest scholar and historian of the day.

FIGURE 16. *Insular half-uncial script: the Lindisfarne Gospels, c. 698 A.D. (British Library)*

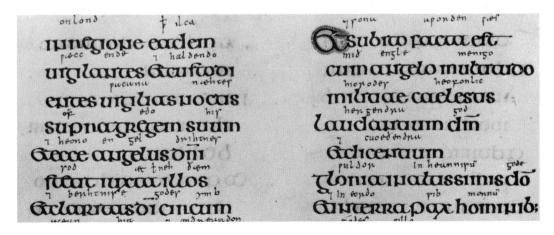

The Carolingian Renaissance

We have seen how the great classical culture declined during the Dark Ages, and at the same time how a Christian culture emerged in the West. A principal figure behind the revision of biblical, liturgical and other texts was Alcuin of York and his career is an interesting link between English scholarship such as Bede's and the revival of learning under Charlemagne.

The first half of Alcuin's life was spent as a scholar at York, a school founded by Egbert, a pupil of Bede. In 767, Aethelberht became Archbishop of York and left the immediate direction of his school to Alcuin. He became the centre of a notable

FIGURE 17. *'Hierarchy of scripts' in a Carolingian manuscript. Roman monumental capitals, uncials, half-uncials and Rustic Capitals (B.L. Add. MS 10546). (By courtesy of the British Library)*

> *inuicem·ē·fidem uram atque meam·*
> *Nolo autem uos ignorare fratres· quia*
> *saepe proposui uenire aduos· et prohibitus*
> *sum usq:adhuc utaliquem fructum habea*
> *et inuobis· sicut et inceteris gentibus·*
> *Graecis acbarbaris· sapientab: et insipientab:*
> *debitor sum· Ita quod inme prumptum ē·*

FIGURE 18. *Caroline minuscule. From the Grandval Bible written at Tours, early 9th century (B.L. Add. MS 10546). (By courtesy of the British Library)*

group of scholars over the next 13 years and made excursions to Rome to visit centres of learning in Italy and Gaul. On a third Roman journey he was received on his way home at Parma by Charlemagne, who offered hospitality at the Frankish court. After this meeting Charlemagne appointed Alcuin as his chief adviser at his Palace School at Aachen. Alcuin impressed upon Charlemagne his duties as a great Christian king and worthy successor to the Romans: he was to instil in his subjects a sense of loyalty and unity by stimulating the production of luxurious works of calligraphy and illumination. Thus the Franks would show that they were no longer barbarians, and show themselves as natural heirs of the Romans.

This marked the beginning of the Carolingian Renaissance, whose significance for the future of calligraphy was of the utmost importance. Charlemagne was crowned Emperor of the Holy Roman Empire in 800 and a European civilization was born, stretching from Holstein to Barcelona and Benevento, from the Elbe to the Atlantic.

Charlemagne's main ambition was the rebirth and renewal of cultural life, and to achieve this books were essential for churches and monasteries, for schools and libraries; books for reading and for prayer. In 796 Charlemagne appointed Alcuin abbot of the great abbey of S. Martin at Tours, where he died at the age of 70 in 804. While there, he converted this largely undistinguished monastery into a great centre of learning and further developed there the beautiful round minuscule hand known as Caroline Minuscule (see Fig. 18).

The majuscule scripts of late antiquity were revived and used with the new minuscule for chapter headings, sub-headings and endings. This alternating of scripts gave great clarity and articulation to a page or book and the concept of a 'hierarchy of scripts' developed (see Fig. 17) which we still use today. The clarity, dignity and beauty of the new script gave it great prestige and it rapidly replaced its various minuscule rivals as a truly international script. Charlemagne's major reforms included a new and standard text of the Benedictine Rule and a revision of the Vulgate and the liturgy, and it was these revisions which were the main vehicles for the new script. In England, the Danish

FIGURE 19. *English Caroline minuscule from the last quarter of the 10th century (the* Ramsey Psalter, *B.L. Harley MS 2904). This is the script used by Edward Johnston as the basis for his 'Foundational Hand.' (By courtesy of the British Library)*

invasions all but destroyed monastic life and it was not until the 10th-century Benedictine revival that the Caroline script was introduced to this country (see Fig. 19), gradually gaining the ascendancy over the native Anglo-Saxon minuscule; thenceforth a whole series of distinctive books began to appear from the scriptoria of Abingdon, Winchester, Exeter, Glastonbury, Ramsey, Malmesbury, Sherborne, Bury St. Edmunds and Peterborough.

Gothic

For four centuries the Carolingian heritage remained substantially unaltered, but the script underwent continual, almost imperceptible change, acquiring all the time artificial elements like hairlines, hooks and flourishes. Gradually, a break from the roundness of Caroline minuscule towards the angularity of the Gothic script was taking place. This began to show by the end of the 12th century coincident with the advent of Gothic architecture.

The death in 911 of the last of the Carolingian dynasty, Louis the Child, caused a shift in the balance of power within the Frankish kingdom towards the German-speaking East Franks, with the coming to power of Otto I. It was he who re-established the Holy Roman Empire by having himself crowned Emperor in 962 and continued the Carolingian traditions in Germany. During the 11th century the Ottonian German Empire was the paramount power in Europe until the West Franks, under Hugh Capet, had established a new culture and were able to challenge Germany in the 12th century.

An important factor in the French cultural revival was the invention in architecture of the pointed arch which exerted less thrust than the semi-circular, and the self-supporting rib vault and flying buttress. A succession of great cathedrals followed, such as Chartres (1220) and Amiens (1248), cathedrals so magnificent that the new art spread throughout Europe. France had created a new 'modern' style and once more a power shift was taking place in western Europe, with a departure from the Old Carolingian canons.

The emergence of Paris in the late 12th and early 13th centuries as a university centre gave an opportunity for developing

FIGURE 20. *Gothic script (textura) of the 14th century (French). A copy of the Mass of Christmas and St. Stephen. (Vatican Library)*

the Gothic or 'Black Letter' script which became more angular and decorative (see Fig. 20). The spread of learning, and legal studies in particular, introduced a whole new breed of scribes, the professional scriveners, and the expansion of schools and universities brought in greater scribal autonomy, the 'modern' style becoming over-decorative and illegible. The introduction of a cursive variety (*Bastarda* – see Fig. 21) completed the de-Romanizing process. But as with all things that are over-designed, it became too elaborate to be practical and it eventually led to a neo-Carolingian reaction.

The acceptance of Gothic south of the Alps was only slow and partial. French Dominicans introduced the new style and in 1280 commenced building the 'Gothic' church of Santa Maria sopra Minerva, but a rounded form of Gothic script (see Fig. 22), produced at Bologna at the end of the 13th century, remained dominant in Italy.

In the early 14th century Italy played an important part in a new art evolution. There had been a gradual fading of the Byzantine influence in the arts and Cimabue was the last painter in the Byzantine style. Giotto introduced realistic space and monumental form which heralded a new style – the ideal of the future Renaissance. A new feeling of Italian patriotism sprang up and Gothic became repugnant as it now represented France.

FIGURE 21. *Gothic cursive (Bastarda) script (B.L. Lansdowne MS 851). (By courtesy of the British Library)*

FIGURE 22. *Gothic script (rotunda) of the 14th century (Italian). A copy of the Decretals. (Vatican Library)*

Renaissance

The Italian Renaissance (1300–1550 approx.) marked a new watershed for the future of scripts and type. Among other things the Renaissance transformed the transmission and study of classical antiquity. The movement started in a quiet way in the mid-13th century but it was Petrarch (1304–74) who was the first great Renaissance scholar and poet. With his great enthusiasm he was able to communicate to others the classical spirit, trying to revive within the framework of a Christian society the ideals of ancient Rome. The resiting of the Papal Curia from Rome to Avignon in the 14th century was fortunate for Petrarch, as Avignon was much more suited as a point of cultural contact between the north and the south and attracted to the papal court men of different nationalities and intellectual outlook. Avignon thus provided a link between the Middle Ages and the Renaissance.

Among the next great wave of humanists was Poggio Bracciolini, who combined his official post of papal secretary with an indulgence in literary pursuits. He made a number of expeditions to find important monasteries and ancient manuscripts and his most important rediscovery was of the Caroline minuscule script; the earliest book written by him in his version of this hand is dated 1402–3. The cursive version of this 'Humanist' script, now known to us as italic, has slightly more obscure beginnings but the sponsorship of the new script has been attributed to Niccolo Niccoli.

The enthusiasm for the new hand was such that a printed writing book to teach

FIGURE 23. *An example of the Humanist cursive script of Palatino, one of the great 'writing masters' of the Italian Renaissance.*

FIGURE 24. *Humanistic minuscule dated 1436. A copy of the Terence Comedies. (Vatican Library)*

italic was produced in Rome in 1522 by Ludovico degli Arrighi. It was entitled '*La Operina*' and was printed from engraved wood blocks (technically woodcuts as they were cut on the plank rather than the end grain). This heralded a whole succession of similar books by masters such as Tagliente, Mercator, Palatino (see Fig. 23), Casper Neff, Vespasiano Amphiareo, Juan de Yciar, G. F. Cresci and Francisco Lucas.

Printing

The discovery of the art of printing by movable type is generally attributed to Johann Gutenberg of Mainz between 1440 and 1450, but again, the true facts have become obscured. The first printed edition of the Bible appeared in 1456 by the combined efforts of Gutenberg, Fust and Schoeffer. This famous edition, printed in the Gothic style, is known as the '42-line Bible' from the number of lines in a column of the page. The invention found its way to Italy and Venice became a great centre for printing with the Frenchman Nicolas Jenson as the most notable personality, especially for the beauty of his Roman type.

German craftsmen later took the invention to France where Paris, Lyon and Rouen became the important centres, and then to Holland whence Caxton introduced it into England in 1476.

The first printed books were called incunabula because of their resemblance to manuscripts, but type had freed itself from calligraphic influence by 1500, when Aldus Manutius invented the small octavo book, convenient for the student. This required a smaller type quite different from the written forms. In 1501, Aldus published in Venice the first of a famous series of classics printed in italic type. However, as is now well known, cursive scripts are more difficult to read than formal ones, so that it was eventually the Roman type based on the Humanist versions of the old Carolingian hands that won the day (see Fig. 24) and italic was reserved as a means of differentiation such as for quotations, foreign words, titles, emphases and so on.

Strangely enough, the old Gothic types retained their popularity in Germany and the type we know as Fraktur was developed under the patronage of Emperor Maximilian, who was anxious that the familiar Black Letter should hold its position. It is quite extraordinary that Fraktur managed to maintain this status as the principal type

COPY No. 1. *After* WINCHESTER FORMAL WRITING about 975 A.D.

Et haec scribimus vobis ut gaudeatis, & gaudium vestrum sit plenum.

Et haec est annunciatio, quam audivimus ab eo, & annunciamus vobis: Quoniam Deus lux est, & tenebrae in eo non sunt ullae.

Note: *This copy is written with a pen, not printed* E.J. 31 May-1 June 1918. A.D.

Henry Italics' based on Winchester MS. Winchester MS. very slightly modified.

In order that a child may learn how to write well the teaching of handwriting should begin with the practice of a Formal Hand. This Manuscript is written with a BROAD-NIBBED PEN which makes the strokes thick or thin according to the direction in which it moves. The strokes are generally begun downwards or forwards & the letters are formed of several strokes *(the pen being lifted after each stroke)*: thus *c* consists of *two* strokes, the first a long curve down, the second a short curve forward. The triangular 'heads' *(as for b or d)* are made by *three* strokes; 1st. a short thick

abcx'l

curve down, 2nd. a short thin stroke up *(the nib for this stroke being placed on the beginning of the first and slid up to the right)*, 3rd. the thick straight *stem* stroke of the letter itself down *(the pen for this stroke not being lifted)*.

Broad-nibbed steel pens and Reeds may be used: Quill pens are very good but require special cutting. How to cut Quill and Reed pens may be learned from my Handbook "Writing & Illuminating, & Lettering" *(John Hogg, London: 6s. 6d. net)* besides how to make MS. Books and to write in colour. Edward Johnston: *Ditchling, Sussex.*

THIS SHEET IS PUBLISHED BY DOUGLAS PEPLER at HAMPSHIRE HOUSE HAMMERSMITH 1916 A.D.

Price 5/-

Reduced on a/e of erasures to 2/6

of Germany right down to World War II, when it was denounced by Hitler as a Jewish invention.

Modern Calligraphy

A vigorous and craftsmanlike tradition of pen lettering, based on Black Letter, survived in Germany until World War II and even after, thanks to such teachers as Rudolf Koch (1876–1934) and Ernst Schneidler (1882–1956), both of whom, as well as many of their students, were involved with graphics and type design as well as calligraphy. In Britain, however, any pretence at a sound typographic and calligraphic tradition had, by the mid-19th century, virtually ceased to exist; scholars and paleographers admired the beauty and clarity of medieval and Renaissance scripts, but had no idea how they had been produced. Victorian ladies passed their leisure time in producing 'illumination' and followed the lead of Henry Shaw and other experts by drawing the letters in outline and filling them in.

The tide began to turn with the growth of the Arts and Crafts movement in the 1880s, with its emphasis on the value of workmanship and insistence on first-hand knowledge of tools, materials and methods. William Morris, while studying manuscripts in preparation for the setting up of the Kelmscott Press, made experiments in writing with an edged pen. But the real breakthrough came with the original researches of Edward Johnston (1872–1944). With the encouragement of W. R. Lethaby and Sydney Cockerell, and through first-hand examination of manuscripts in the British Museum, he virtually rediscovered the broad-edged pen and its significance in

FIGURE 25. *A 1916 advertising sheet promoting Edward Johnston's influential work* Writing and Illuminating, and Lettering.

the design evolution of the Western alphabet. In his subsequent teaching he laid down specific guidelines for the study of historical hands which, when fully appreciated, provide an indispensable analysis of letter forms. His book *Writing and Illuminating, and Lettering*, published in 1906 (see Fig. 25), was immensely influential. Translated into German by his pupil Anna Simons, it proved almost as effective as Hitler in weaning Germany away from Fraktur; and in the United States, John Howard Benson, who was to become America's foremost lettering craftsman, carried his copy about with him until it all but fell apart.

Johnston's students (Irene Wellington and Graily Hewitt foremost among them), and his students' students, maintained a strong teaching tradition based on his principles in British art schools all through the 1940s and 1950s. At the same time, lettercarving under the influence of Eric Gill (1882–1940) and typography under the influence of Stanley Morison (1889–1967), both of whom acknowledged their debt to Johnston's work, reached new heights of excellence, so that English craftsmanship gained a worldwide reputation.

Abruptly, at the beginning of the 1960s, the teaching of lettering in the art schools was terminated, so that the entire base for the training which had produced this excellence was all but wiped out. The Society of Scribes and Illuminators, founded by students of Johnston in 1921, continues to thrive, and much has been made of a recent upsurge of interest, particularly in the United States, in calligraphy as an art form. But without the solid, systematic teaching that enables an appreciation and use of sound lettering to form part of our daily lives, the time may not be too far off when the craft will die once more, and require another Johnston to rediscover it.

METHODS AND MATERIALS

THE first consideration for any calligrapher is (naturally enough) the pen; and for most this means a broad metal nib supplied with a reservoir for holding and dispensing a supply of ink and set into a penholder. A well-cut quill remains the best and most responsive writing instrument, but it requires constant attention, and until relatively recently was made unnecessary for everyday lettering use by the availability of several makes of high-quality metal pens. Now both the quantity and quality of metal pens have diminished to such an extent that in the not too distant future the pen-letterer may find himself once more cutting his own quills and reeds.

For our purposes we need a pen which must be fed separately, either with a brush or by dipping. Fountain pens are convenient, but fail on two counts: in spite of manufacturers' claims, no fountain pen can use really good quality ink for long without clogging; and the widest nib available in fountain pen sets is generally too narrow for beginning work, which must be large and clear enough for mistakes to be seen and corrected. Fibre-tip pens – at least for the first five minutes of use, while their edges are new and sharp – can be useful for quick roughs and thumbnail layouts, but no more than that.

The 3 mm nib appropriate to the models in this book may be either straight-cut or oblique, to suit the peculiarities of right-hander and lefthander (see Fig. 1). It should be set far enough into the penholder so that it is firm and does not wiggle. Most penholders have a central metal or plastic core; make sure that the barrel of the nib is between this core and the outer casing (see Fig. 3).

Some penholders come with a built-in reservoir, in which case the ink flow must be regulated by pushing the nib itself in and out, which can be a messy business. Some nibs, notably German ones, have a reservoir on top of the nib, which limits the supply of ink considerably and makes it difficult to remove the reservoir for cleaning. The most familiar sort of reservoir is the small, brass 'slip on', which goes on underneath, with its tip about 2 mm ($\frac{1}{12}$ in) from the end of the nib (see Fig. 2).

Usually the reservoir will require a certain amount of adjustment to tailor it to a particular nib. Hold the pen vertically against a window and look at the back of

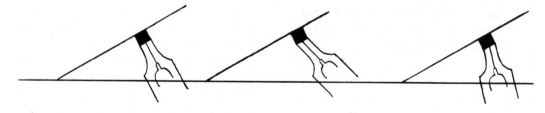

FIGURE 1. *Straight-cut, right-oblique and left-oblique nibs.*

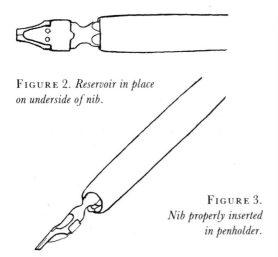

FIGURE 2. *Reservoir in place on underside of nib.*

FIGURE 3. *Nib properly inserted in penholder.*

the nib. If daylight can be seen between its halves, the tongue of the reservoir is probably bent up too far against the underside of the nib. Remove it and bend the tongue delicately downwards with your little fingernail; then replace it and examine the nib from the side. Now daylight can probably be seen between the tip of the reservoir's tongue and the underside of the nib, which means it must be removed and bent upwards again until it just touches, but does not press. Do not try to bend the reservoir upwards while it is in place – you will only flatten it, and reduce its ink-holding capacity. Make sure that, while it sits firmly on the nib, it can readily be slid on and off; if it is too tight it will cause distortion. It may be necessary to bend its ears back slightly. If daylight can still be seen between the halves of the nib when the reservoir is off, the nib has given up the ghost and must be thrown away.

When properly in place, and with a good store of ink behind it, the reservoir should supply the ink in a small, steady stream – not too fast, not too slow – enabling the pen to write sharply and cleanly and for as long as possible without replenishing. Adjusting the reservoir towards the tip of the nib

should increase the flow of ink; adjusting towards the back should retard it. When the pen needs refilling, the cleanest and most professional method is to use a short-haired brush, held in the non-writing hand, to stroke ink in directly behind the reservoir, taking care to keep the top of the nib clean. The brush can then be turned and its non-business end used to hold down the work as the writing progresses, in the same way that medieval and Renaissance scribes are represented using a stylus or knife – but do not get absent-minded and forget which end is which! Those of us who are lazy, however, use the dip-and-wipe method which is often messy, but is also much more convenient. With this method the inkpot is on the writing side, along with a lint-free rag (no tissue paper or paper towels) and the pen is dipped just far enough to submerge the reservoir; then the back of the nib is touched to the cloth to clear it of ink. A light dab or two is enough; too much wiping will empty the reservoir. If the ink or colour will not flow readily from the reservoir, it is probably too thick. In this case the reservoir may be dispensed with altogether and the ink piled up on the back of the nib with the brush, a method that requires considerably more skill and control.

Under ordinary circumstances, efficient writing and lettering can be done only on a slated surface; and for this we need a board. It should be rigid – three-quarter-inch plywood or blockboard is good and flat, with no warping or twisting – and it should be large enough to cope with paper sizes up to A2, but not so large that you cannot reach your materials conveniently. A good size is 24 by 30 in (610 by 760 mm). Such a board could, if necessary, be held on your lap and propped against a table; obviously better, however, would be an independent arrangement allowing for

adjustment of the angle of slant. The simplest solution, available to anyone who can use a screwdriver, is still that shown by Edward Johnston in *Writing and Illuminating, and Lettering* (see Fig. 4). It is also a relatively simple matter to make a board

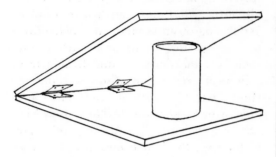

FIGURE 4. *Boards hinged together with moveable support (such as round tin).*

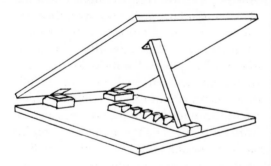

FIGURE 5. *Boards hinged on blocks, with single hinged support fitting into notched strip attached to base.*

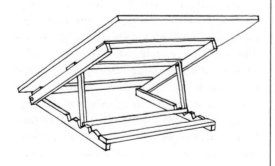

FIGURE 6. *Separate board resting on table easel.*

with an adjustable support (see Fig. 5). A third alternative is to use the board on a table easel (see Fig. 6). At the top of the scale is the professional drafting table. Such tables are prohibitively expensive, and generally so large that sooner or later you will be tempted to put pen and ink on your sloping board instead of beside it, with resulting grief and disaster.

The board should be right-angled all round, but only the left-hand edge need be absolutely straight, to allow the use of a T-square for ruling lines. Its entire surface should be covered with a backing sheet, to offer a resilient surface for the pen to write on. Thick, smooth blotting paper is good for this, but a couple of sheets of heavyweight cartridge paper will do, as long as they can be stretched and taped tight. Across the lower part of the board runs the guard sheet, which may be made from a folded strip of paper with its fold uppermost, long enough to stretch around to the back of the board on each side, where it can be taped securely. A string can be looped taut around the top of the board to hold large pieces of work at the top; and a curved strip of cardboard can be taped along the board's bottom edge to prevent creasing of oversize paper (see Fig. 7).

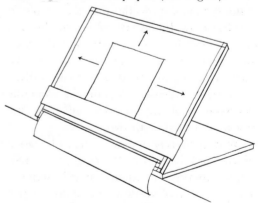

FIGURE 7. *Board set up with backing sheet, guard sheet and protective strip, showing how work can be moved in any direction.*

Position is important. If you are working under uncomfortable conditions you will quickly tire yourself out. Ideally, you should be sitting upright and naturally, both feet on the floor, looking straight at your work, neither reaching up nor hunching down, with arms and elbows free, and your free hand slightly below and to the side of the writing hand. Start with the board at 45 degrees, then adjust the slope to suit yourself. Find the writing level which makes you feel most comfortable, then untape the guard sheet, raise or lower it to 1–1½ in (25–38 mm) below that level and tape it tight again. When all adjustments have been made, it should be possible for you to sit at your ease, working in an area directly in front of you, in an area no more than 9 in (225mm) across, with the shaft of the pen pointing over your shoulder. The work is held by the guard sheet and protected by it from your greasy hands; and except when lines are being ruled it is never taped down, so that when you reach the end of a line, or the limit of your work area, the work itself is moved – never you. Changing the position of the body changes the position of the hands and inevitably the direction of the pen-shaft, with resulting loss of consistency of stroke.

For left-handers, maintaining this consistency presents its own problems, but these are not insuperable: witness the fact that at least three of the most able contemporary calligraphers in Great Britain are left-handed. The most usual solution appears to lie in the general (but not universal) use of a pen with a left oblique nib; a pen-hold in which the hand is turned as much as possible to the left and the pen-shaft points towards the neck rather than over the left shoulder; and an adjustment of the cant of the paper (see Fig. 8).

The ideal pen-hold is one in which the pen is lightly but firmly gripped between

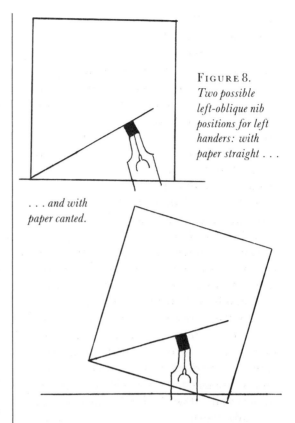

FIGURE 8.
Two possible left-oblique nib positions for left handers: with paper straight . . .

. . . and with paper canted.

thumb and forefinger and supported by the second finger, while the last two fingers curl under to form a cushion on which the whole hand rides while writing. The fingers are used by far the most and should be absolutely free in movement, which means that the forefinger needs to curve outwards rather than in. If you look down at your hand and see a concave forefinger it generally means you are gripping the pen too tightly, with inevitable loss of freedom and lightness of touch. (This is not necessarily true of left-handers; a concave forefinger tends to be a natural feature of the pen-grip described above.) The wrist is also used to a large extent, the arm somewhat less for most writing; but all are used together and all need their freedom. This having been said, it must be admitted that the lettering world is full of calligraphers who often

produce the finest of work with the most unorthodox pen-holds.

The first thing to look for when buying ink is the words 'non-waterproof' on the bottle. Waterproof Indian ink is ideal for drafting, drawing and reproduction work, but its large shellac content means that it will not flow easily from a lettering pen, will not produce sharp, crisp strokes, and will, sooner or later, dry on the pen, making it unusable. The next thing to make sure of is that it is *black* – not blue, blue-black, grey or coloured. The essence of colour work is that it must be flat, opaque and even; no coloured ink has yet achieved this, though many have tried. For finished work, choose the best and blackest carbon ink with the fewest additives – high quality Chinese stick ink, ground down by hand to the required consistency, is still undoubtedly the best. Bottled inks labelled 'Chinese stick ink' or 'non-waterproof Indian ink' are generally reliable but, like most things in life, they cannot be trusted before they are tested.

A good ink substitute can be made from mixing lamp-black gouache with water – in fact, gouache or watercolour mixed with a very small amount of gum arabic and just the right amount of water should be used for all colour work. For roughs and beginning work the inks found in stationers' are a cheaper alternative and often perfectly adequate; but, being stains rather than proper inks, they behave quite differently and should be dispensed with as soon as proper work is begun.

The 'no test, no trust' principle applies to paper even more than to ink. In general, paper which is good for pen lettering must be neither too rough nor too smooth (certainly not glossy or coated), but should have a slight 'tooth' to offer some purchase to the pen. On too smooth a surface the pen lacks control; on too absorbent a surface the ink spreads and the necessary sharpness is lost. Handmade paper is usually the best, certainly the most durable, and is well worth the extra cost not least because, unlike mould-made or machine-made paper, it can take a great deal of punishment, and makes near-invisible erasures possible. It is often possible to tell by the feel of the paper whether or not it will be right for your purposes; but it must be said that, time and again, papers which feel marvellous prove impossible to write on. If you find a paper which does work well, get as much of it as you can lay your hands on, and treasure it. It is often possible to improve the surface of a difficult paper by burnishing it or sizing it to suit yourself.

For the purposes of this workbook (as mentioned in the Introduction), you begin by using paper transparent enough to allow you to work directly from the models. The problem here is finding a paper which can be clearly seen through and at the same time offers the surface qualities mentioned above. Tracing paper or detail paper is generally no good, allowing neither sharpness nor control. Layout paper can be a good and relatively inexpensive alternative, but must be very carefully chosen – the kinds which cost the most and try the hardest to be like tracing paper are usually the least suitable. Lightweight stationery, like that designed for air mail, is often usable, so long as it is white, unlined and at least A4 size. White mould- or machine-made paper, in its lightest weight, can often be quite readily seen through and can be bought in large sheets which are then cut down to size. Beginning work should not be done on small scraps of paper – give yourself plenty of space to work with from the very start for proper line spacing and margins (see the chapter on Layout). If possible, use A3 size paper, large enough to lay across two pages at a time.

Provide yourself with a roll of masking tape and use a few small and easily removable bits of it to attach the transparent overlay paper to (for example) the first page of the first of the basic scripts – Roman capitals. The book should, of course, be propped up at a slant, on the principle of starting as you mean to go on. You should have handy – to your right if you are right-handed, to your left if you are left-handed – a *sharp* 'B' pencil, a 3 mm (⅛ in) pen, ink, pen-wiping cloth, and set of sharp double 'B' pencils. If you use the brush-feeding method, both brush and ink should be on the other side, the object being to avoid the passage of ink-filled implements to and fro above your work (or, in this case, your book).

Your board should be close by, set up for freehand work. This means taking a little time, and a trustworthy T-square, to make yourself a set of pattern sheets – guidelines conforming to the letterheights and line spacings of the examples in the book, which can then themselves be used under transparent paper. For each of the three basic scripts, you will need two sets, one for the skeleton forms, the other for the double pencil and pen-made forms together. Take an A3 sheet of white (for example, cartridge) paper and fix it in a temporary manner with masking tape to your board, making sure it is squared up by putting the T-square against the left-hand edge of the board and checking that it and the top edge of the paper line up.

Pairs of lines corresponding to the head- and baselines of the example are then transferred to the pattern sheet by means of careful markings made, with proper line spacing between, repeatedly down the left-hand side of the sheet, from which the lines are ruled with the T-square (held snugly against the working edge) and a monoline ruling pen. The transferring can be done by

means of measuring (the height of the skeleton Roman caps, for example, is 3 cm, and a reasonable line spacing would be 1 cm); but an easier method would be to provide yourself with two pairs of dividers, set one to the letter-height and the other to the space between lines and step them alternately down the left-hand side of the sheet, leaving precise pin-prick holes into which the point of your ruling pen or pencil can be placed and the edge of the T-square brought up tight against it before the line is drawn. (Dividers, in fact, are extremely useful devices for layout purposes; once they are set to a certain distance, they do not forget it, and on a complicated project you may find yourself with a row of six or seven, each representing a different letter-height or line-space).

Take time to do it right. The accurate ruling of lines is not a lovable art, but a necessary one. When you are done, go to the right-hand edge and check all the intervals thoroughly to make sure they are really what they seem. Once you have made a good, accurate pattern sheet, put clearly at the top the script and nib-size it corresponds to, and keep it forever. When used, it should never be taped down – attach to it a sheet of A3 paper lightweight enough so that the lines show through, and put the whole behind the guard sheet, treating it as one piece of work which can be moved about. When one top sheet is used up, put another on, and do not absentmindedly start writing on the pattern sheet itself.

Each of the basic scripts is divided into groups of letters related to one another through form or method or both; these groups are best worked on one by one, to give your fingers a feeling for the logic behind the forms. Start with the first letter of the first group of Roman capitals: the letter 'O'. Holding your pencil as you

would a pen, draw the form quickly and firmly, following the stroke sequence without sketching or pressing. Repeat the procedure with the other skeleton letters in the first group. Do not worry about reproducing the forms exactly; think of it not as tracing, but as a process of getting acquainted. Turn then to your board and write the letters freehand, using the appropriate pattern sheet under its overlay. Try not to become obsessed with one letter; write them interchangeably, paying attention to their spacing and the way they relate to one another (see the chapter on Spacing and Layout).

You now have in your mind the 'X-ray' version of the letters – the bones on which flesh must be put. The best way to visualize this process is through the use of double pencils, duplicating the action of the pen while being able to see with X-ray clarity what is going on and (even more important) what you are doing wrong. This very useful tool is made with two sharp 'B' or 'HB' pencils, each shaved flat down one side and bound together, not with string or tape, but with rubber bands, so that the points may be adjusted to the proper 3 mm width and shifted to produce a right or left oblique stroke if desired (see Fig. 9).

Each double-pencil letter is provided with an indication of the pen-angle at which it was written. Using the double pencils as a pen, and constantly checking the angle against this line, write swiftly through the first 'family'. Concentrate on keeping an equal but extremely light pressure on both points – if one line is darker, it means that you are bearing down on one side or the other. Do not worry about the straightness of the vertical strokes or the roundness of the curves; the object of the exercise at this stage is not to make perfect copies but to acquire understanding. Keep checking to make sure that the angle of

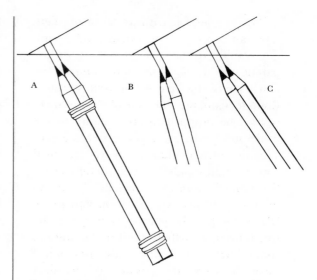

FIGURE 9. *Adjustment of double pencils to produce effect of* (A) *straight-cut nib,* (B) *left-oblique nib,* (C) *right-oblique nib.*

your 'pen' is constant, and that the thinnest points of the round letters – where the two overlapping circles cross each other – are each the same distance from the head- and baseline respectively.

Now for the pen itself. Make sure first that it is working properly. Many new nibs benefit from being run under hot water and dried before use, or drawn briefly through a match flame, to get rid of grease. Once firmly in its penholder, and well supplied with ink, it ought to be possible to start the ink flowing from the nib by placing it square against the paper and drawing it slightly first one way, then the other, along its thin stroke (see Fig. 10).

Three of these 'wiggles' should be enough to produce the sudden easing of friction which means that the ink is coming. If you must scrub repeatedly to produce an ink-flow, something (usually the nib itself, sometimes the paper) is badly wrong and must be corrected before you proceed. Once the ink seems to be flowing

FIGURE 10. *Start the ink flowing by moving the pen first one way and then the other along its thin stroke.*

FIGURE 11. *Testing the flow of ink.*

well, begin to draw the thin stroke out further; the ink should continue to flow without interruption and without undue pressure (see Fig. 11). If the pen passes the second test, it should serve you well, so long as you continue to use it with the lightest possible pressure and, after every use, take the reservoir off and wipe it scrupulously. If a new nib refuses to work, there is little that can be done other than to throw it away and try another.

Once the nib is working, exercise it. Start by going over the double-pencil forms you have practised, on which you still have the directional strokes and pen-angle to help you; then try the pen-made form proper, on which there is no such help. As you acquire

confidence, go to the appropriate freehand sheet and see how you do, referring back to the examples whenever you feel hesitant. Experiment with pen-angle if you feel like it, bearing in mind that, whichever angle you choose, it must remain constant except with regard to angled letters, and that the angle for the Roman alphabet, both minuscule and caps, should not be over 30 degrees; otherwise vertical strokes become too thin, horizontal strokes become too thick, feet become too heavy (see Fig. 12) and round letters tend to roll over backwards (see Fig. 13).

As you acquire more letters, begin, as soon as possible and even sooner, to put them together into words and sentences. Pen lettering is not a matter of perfectly formed individual letters, but of problems and decisions of weight, spacing and layout which attack from all directions at once. The sooner this fact is confronted, the better. In Johnston's words, 'Writing out alphabets only teaches you to write out alphabets'. Real progress is made, not by practising letters, but by using them – setting yourself projects, no matter how simple, which are carried out to the very end before going on to new ones. By the time you have worked thoroughly through the three basic scripts that follow, you should have the tools you need to proceed. They are like the basic chords on a guitar; learn them and you have access to tens of thousands of tunes.

FIGURE 12. *Straight-stroke letter written with the proper pen-angle (left) and an over-steep pen-angle (right).*

FIGURE 13. *Round letter written with the proper pen-angle (left) and an over-steep pen-angle (right).*

ROMAN CAPITALS

CALLIGRAPHY instruction manuals tend to begin with Roman minuscule ('foundational') as the script which, being the most uniform in shape and subject to the least amount of pen manipulation, is the best starting point for beginners. We have chosen to examine Roman capitals first for two reasons: they came first chronologically, forming the basis for the Latin scripts that followed, and they tend in general to be insufficiently studied. Many a beginning and intermediate piece of work has failed because the writer, expert in the main script of the text, was suddenly faced with using a capital letter (or numerals, another vulnerable point).

Capitals (or 'majuscules') are, admittedly, difficult and often awkward to render successfully with a broad pen. Although their forms obviously depend on the interplay of thick and thin, they were not developed through use of a rigid edged instrument held at a constant angle. Examination of the examples in the historical introduction shows that the best of the carved Roman inscriptions probably depended on being written out beforehand by a skilfully wielded flat brush, producing subtleties which we can only approximate with the pen as we try to produce a version of this alphabet consistent with the look of the direct and naturally pen-made scripts which follow. The principles of spacing and optical correction of forms which the Roman lettering craftsmen developed over generations and which reached their most advanced form in the great Roman capital inscriptions of the 2nd century are fully as important to the calligrapher of today as to the signwriter or lettercarver, and call for thorough study. This is only the most cursory of introductions.

ABCDEFG

HIJKLMNO

PQRSTUV

WXYZ

1234567890

&!?

Most of these letters belong to three 'families' of widths. The first group is based on a square:

O Q C D G
M W

The form of 'O' governs all arched and curved letters of the Roman alphabet. Having made the left-hand curve, start the right-hand curve part way along it, 'in the black', and follow the curve around. Think of the O-shape as being more towards the outer edge than the inner; the 'counter', or white space within the letter, should look not like a circle, but an oval shape. The whole letter should 'cut' the lines slightly above and below; otherwise it will look too small.

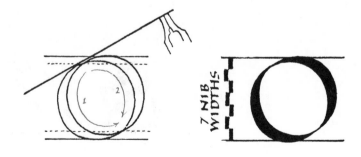

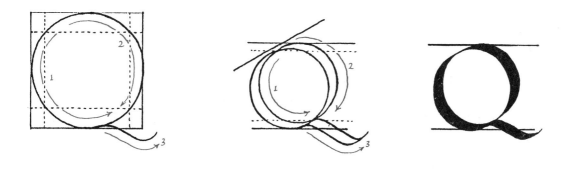

Form the 'Q' exactly like the 'O', then lead the tail out of it from a point slightly to the right and above the baseline. The tail should flourish, not flop.

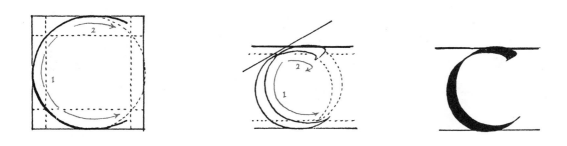

Note that both 'C' and 'D' are flattened top and bottom, giving a more elegant shape and leading the eye along the headline. Neither letter should give the slightest impression of an 'O' with a bit cut out of it.

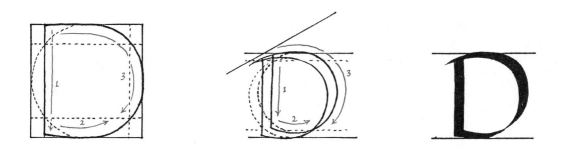

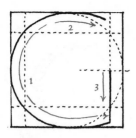 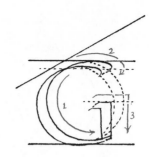

'G' follows the same pattern as 'C'. Its distinguishing vertical stroke should come up to the horizontal centre line, but no further, and should line up with the end of the top stroke.

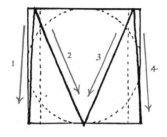 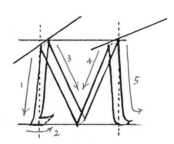

'M' is probably the most difficult of the capital letters to translate successfully into directly pen-written terms, involving as it does at least two different pen-angles. It consists of widened V-shape fitted with legs which are slightly off the perpendicular. Spread them too far and the letter looks like a man on ice with his feet going out from underneath him. 'W' is comparatively straightforward – two narrowed 'V' forms. Please note that M is *not* an upside-down W. W is *not* an upside-down M.

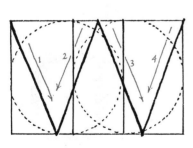 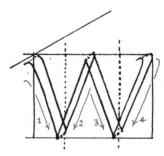

The second group is based on one-half of a square:

In order to make the letters look complete, finishing strokes (or 'serifs') are necessary. Those appropriate to pen-made Roman capitals look so:

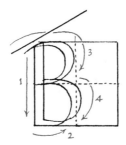

If both bowls of strokes in 'B' are made equal, as one is tempted to do, the letter will look top-heavy. The upper bowl is therefore reduced just enough to produce the right optical balance; the join comes just above the centre line, not on it.

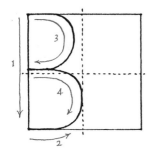

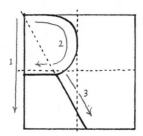 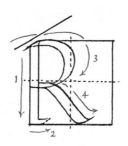

Here the bowl is approximately the same size as the lower bowl of the 'B' and should flow in and out of the stem in a natural movement. You may, if necessary, use as many as three strokes to produce a neat join of bowl and tail, but it should never *look* as though you have. The tail should have a good rolling snap to it – not stiff and straight, nor limp and floppy – but should not be drawn out too far, except at the end of a line. It should not droop below the baseline. The bowl of 'P' should be slightly larger than that of 'R'.

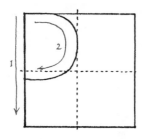 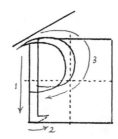

The horizontal strokes of 'E' (like those of 'F') should be basically the same length, though the finishing stroke of the bottom one may be drawn out slightly for the sake of balance. The centre stroke should rest on the top of the centre line.

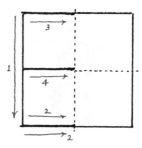 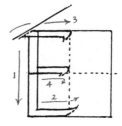

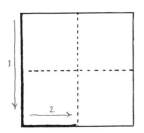 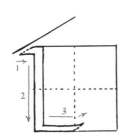

'L' is basically 'E' without the top two strokes. The top stroke of 'F', like that of 'E', should be just under the headline, not on it, but the centre stroke should be slightly lower than that of 'E', to avoid looking too high.

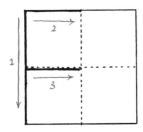 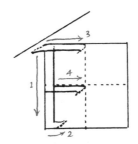

The top part of 'K' holds slightly less air than the bottom and joins the stem just on top of the centre line. The tail, like those of 'Q' and 'R', should have a flourish to it, but except at the end of a line should not be drawn out too far – otherwise you will create spacing problems for yourself.

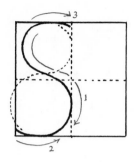 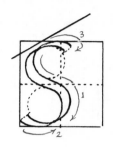

A good way to visualize 'S' is to imagine (or sketch) a smaller circle on top of a slightly larger one and use this as a basis for your double curve. If you make the form dead upright, the finished letter will tend to look as though it is falling backward, so the top circle should be shifted slightly to the right, as shown.

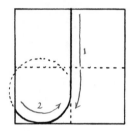 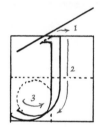

'J', not being found in the original Roman alphabet, must be adapted from 'I'.

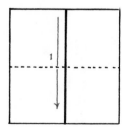 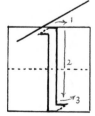

The width of the third group is a little more than three-quarters of a square. The width of this rectangle can be visualized by placing a circle within a square, dividing it as shown, and adjusting the sides of the inner rectangle until the shaded portions are visually the same. From this starting point, the letters may be made slightly wider or narrower, as you wish – so long as all changes are consistent.

Letters involving diagonal strokes demand a steeper pen-angle and some manipulation. The rest retain the usual flatter angle.

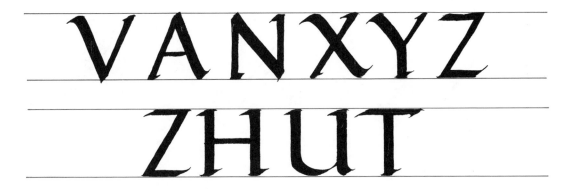

The serifs of diagonal strokes are usually tightly curved.

'A' is basically an upside-down 'V'. The legs of both are spread slightly beyond the rectangle to avoid giving too narrow an appearance. The centre stroke of 'A' is often placed too high; its position can best be judged by striking a vertical line from the *bottom* of the upper join to the baseline and finding its halfway point. Note that 'V', 'A' and 'N' all extend slightly beyond the head or baseline, to avoid looking too short.

It is all too easy to think of 'N', like 'H', as being a square letter. Resist the temptation! Do not be bothered by the fact that the joins are cut off, not pointed.

The strokes of 'X' cross each other just above the centre line, making the top of the letter slightly smaller, for the sake of optical balance. Note that in the pen-made form the top and bottom V-shapes move slightly out of line with each other.

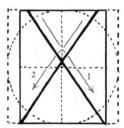 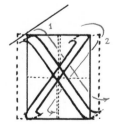

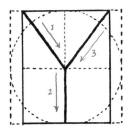 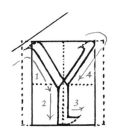

The upper half of 'Y', unlike 'X', spreads the full width of the rectangle. The join falls on the centre line, not above or below it.

Many contemporary calligraphers prefer the 'Z' to be done with a flatter pen-angle, as below. However it is done, the principle remains the same: to produce the same sort of contrast between thick and thin as is found in the rest of the alphabet.

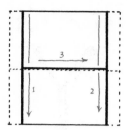 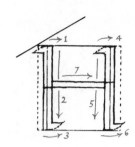

The cross stroke of 'H' sits on top of the centre line. Be reminded: like 'N', it is *not* a square letter.

The curve of 'U' takes its cue from the curve of the 'O', but does not follow it exactly – it needs to be dropped slightly in order not to appear too high.

Keep the cross stroke of 'T' as short as you dare. It should be just under the headline, not on it – the over-tall 'T' is the curse of much beginning work.

Ranging numerals

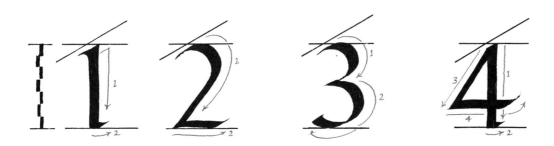

These are written at full capital height, and are generally considered appropriate for use with capitals. Considering that they come from Arabic forms which developed quite independently of Western influence, they adapt remarkably well for use with Western writing.

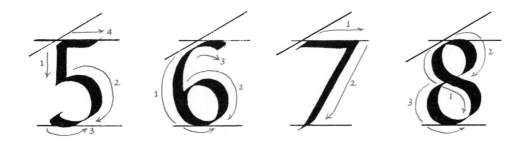

The symbol for 'and' known as an 'ampersand' comes in many variations; here is a capital-height version in which the original joining of 'e' and 't' to form the Latin *et* is just barely recognizable.

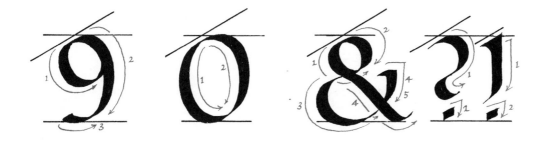

'ROMAN' MINUSCULE

ROMAN MINUSCULE is an inaccurate term, since the Romans had no alphabet of small (*minuscula*) letters. The script would more accurately be called 'Humanist minuscule', since we know the forms familiar to us in most printed books through the efforts of 15th-century Italian Humanist scribes who, having no genuinely classical models of small letters to work from, ingeniously adapted Carolingian letterforms to their own purposes. The fact that these scripts postdated Roman and Greek classical origins by six hundred years and more bothered them not at all; they could see that there was a close family resemblance. The earliest printers, also working in Italy, cut type to these models and called it 'roman', and so we have known it ever since. The script is sometimes called 'round hand', also a misnomer, referring as it does to a version of 18th- and 19th-century commercial copperplate, though there is no denying that it *is* round. A better alternative is 'foundational', since Edward Johnston (who, it must be said, was also partial to the term 'round hand') used his own version of a 10th-century English Caroline script (B.M. Harley 2904) as a basis for his own teaching, and it has remained as a 'foundation' for beginning instruction in most British courses and manuals ever since. As Ann Camp notes in her *Pen Lettering*: "It is the basic hand from which all variations of form and weight may spring."

abcdefghij

klmnopqrs

tuvwxyz

1223344 5

6 7 8 9 0

" & ! ? ; "

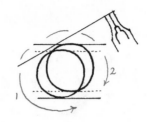
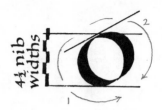

The 'o' is the mother of the Roman alphabet, and of the Caroline and Humanist minuscules which came after it and on which this minuscule is based. Whether compressed or extended it provides the basic structure for all but a few of the letters which follow. Consistency is vital; once you have chosen the weight and form of your 'o' stick to it.

In the rest of the letters on these two pages, a basic 'o' form is flattened either at top or bottom to avoid over-heavy joins. Serifs on descenders are generally horizontal, like those of capitals; serifs on ascenders may be either tightly curved or built up:

Whereas the top stroke of 'd' needs to be lengthened slightly for the sake of making a neat join with the ascender, the top stroke of 'c' needs to remain short to preserve optical balance and prevent an 'overbite'. Again, note the flattened stroke at the top. None of these forms should have the look of a circle with a bite taken out of it.

The forms of these letters like 'p' and 'd' can be checked one against the other – turn 'q' upside down and it should become 'b'. Ascenders and descenders should be of identical length – here approximately 3½ nib widths.

The mid-strokes of 'a' and 'e' should come up or down no more than halfway, to prevent imbalance. The bowls should not hold too much air – better to have them too small than too large. The outer points of the curves of the bowls should be softened, not sharp.

Be sure to give the lower curves of 'a', 'l', and 't' their full value, following the curve of the 'o'.

A common beginners' mistake is the placing of the cross strokes of 't' and 'f' on the headline or even above it, making them look too high. Like the ear of the 'g', they should be just below the line. Do not make the peak of the 't' any higher than shown.

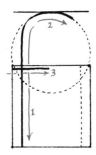 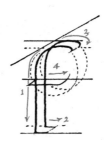

Remember that the top of the 'f' reaches to full ascender height and has a flattened curve similar to 'c'. Descenders, on the other hand, follow the more gradual, fuller 'o' curve. Note how the lower bowl of the 'g' is flattened, taking on an elegant, 'flourished' look, but still containing more air than the circular top bowl.

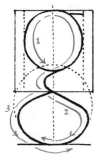

Arched letters demonstrate clearly the 'branching' movement which is central to this alphabet. The stroke should start within the stem, in the dark, and the arch should begin as soon as the pen emerges from the stem into 'daylight', so that a sharp angle is produced between stem and arch. The outside of the letter should look symmetrically rounded; the 'counter' (or white space within the letter) should look distinctly slope-shouldered. The serifs are based on very small, tight curves.

A good way of checking 'n' and 'u' is to turn them upside down; their forms should be interchangeable. The branching stroke of 'u' should be carried right into the stem.

A common beginners' mistake is to make 'm' too narrow. Think of it as two 'n's joined together, each perhaps slightly narrower than the orthodox 'n', but not much.

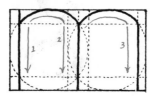 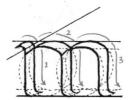

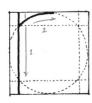

Begin 'r' as you would 'n' and then stop before you get too far; otherwise you will create spacing problems for yourself. An 'r' at the end of a word may be drawn out further and even flourished if appropriate; when followed by 'i' or 't' a ligature may be used.

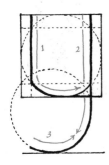 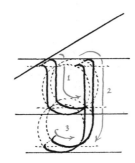

This form of 'y' is simply a 'u' with a tail. Note the roundness of the descender, following the complete shape of the circle – it should not look 'broken'. The u-based 'y' and the 'h' can be checked against each other by the upside-down test.

 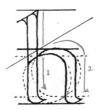

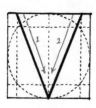 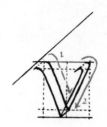

As with capitals, minuscule letters involving diagonal strokes generally demand a steeper pen-angle. This 'v', like the capital form, needs to be symmetrically upright, and to cut the baseline slightly in order not to appear too short.

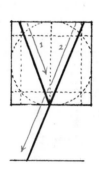 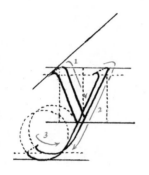

Another form of 'y' is based on the 'v'; its descender can be straight as well as curved. The 'w' is formed of two 'v's, each perhaps slightly compressed, but not too much.

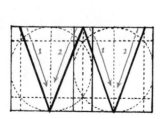

The diagonal strokes of 'x' and 'k' are at a flatter angle; the pen must therefore be held at a slightly flatter angle in order to continue to produce a consistent thick–thin contrast. A less formal version of 'x' can be made so: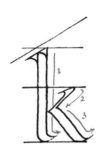

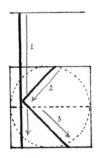

The letter 'z' is simply the capital 'Z' written small. See the 'Roman Capitals' section for comments.

In past years many calligraphers interpreted the lower curve of the 'i' as matching that of 'l' and 't'; in most modern usage it becomes, as above, no more than a serif. It should be one or the other, not something in between. The 'j' needs to have a full roundness to its bottom curve (see 'y' and 'g').

The 's' is another form borrowed directly from the Roman capital alphabet, complete with lower bowl larger than upper for the sake of balance. It tends, however, to be slightly more compressed, and sit more upright.

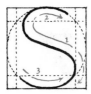 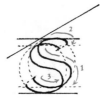

Old style numerals

1 2 2 3 3 4 4

These are written at minuscule height and are therefore usually used with small letters. They give a more graceful and decorative effect than ranging numerals, especially if an even distribution of ascending and descending forms can be arranged (something which is not always possible).

5 6 7 8 9 0

Traditional English usage has put even numbers rising above the headline and odd numbers below; American usage, and much modern calligraphic practice in general, tends to even off the tops of numerals 1 to 5. Both alternatives are shown here, together with a flat-topped '3'. The ampersand is only one of many versions proper for use with small letters.

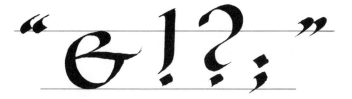

Humanist Cursive
('Italic')

THE term 'italic' is not inaccurate, since the script certainly originated in Italy, its earliest known form having been identified as the work of a Florentine Humanist scholar, Niccolo Niccoli, in the first quarter of the 15th century (see 'A Brief History'). As with 'roman', however, advanced forms of the script were eventually used by printers (notably Aldus) as models for the cutting of type faces, and typographically the term has come to mean, not so much a particular form of letter, but any letter which tilts. This does the script a grave injustice; it has a unique beauty and character which can only be properly appreciated through familiarity with its origins in calligraphy. 'Humanist cursive' would be a better choice. Its close family resemblance to the upright, arched Humanist or 'roman' minuscule is obvious, and with certain reservations noted by James Wardrop in his *The Script of Humanism* it can be taken as the 'cursive' – informal, rapidly written, 'running' – companion form to that script. The relationship between the two becomes clearer if we accept Wardrop's challenge to 'write a roman quickly and see what happens'.

It is the most versatile of scripts. As a system of handwriting (to be revived and fostered by Alfred Fairbank and others from the 1930s onwards) it proved immensely useful, by virtue of its speed and clarity, to scribes toiling away not only, as has sometimes been stated, in the Papal Chancery but in chanceries (i.e. letter-writing departments) of city administrations all over Renaissance Italy. Hence it is also referred to as 'cancelleresca corsiva', or chancery cursive. Soon, however, it was accepted as a formal 'book-hand' in its own right, and it has remained as appropriate to commercial graphic work as to royal proclamations.

abcdefghijk
lmnopqrstu
vwxyz

ABCDEFGHI
JKLMNOPQR
STUVWXYZ

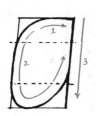

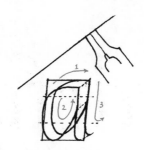

The mother of the italic alphabet is not an elliptical 'o' shape, but an elegant and asymmetrical 'a' shape (above) which defies description. Arrighi's *Operina* of 1522 – the first complete brief introduction to 'Chancery cursive' and still one of the best – defines 'this shape' (*questo corpo*), contained within an 'oblong parallelogram', as that which gives the script its character, and which must be mastered. Only three or four of the rounded letters of the italic alphabet (as we shall see) are directly modelled on the 'o'; the rest are derived, in one way or another, from the 'a' shape, whose form, whether pointed or rounded, joining the stem high up or low down, must remain the same throughout the alphabet. The basic pen-angle is steeper than in the roman, but do not overdo it. The slant of the letter should be no more than as shown – about five degrees.

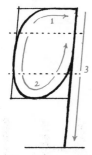

The forms of 'q' and 'b' should be interchangeable – as near as possible the same no matter which way you turn them. It is important to bring the joining stroke of the bowl smoothly into the stem or out of it, and at the same distance from baseline or headline (the dotted line marks the spot). The whole shape of the letter can be largely determined by the placing of this join – a high join will tend to produce a pointed 'a' shape, a low join a rounded one (experiment and see for yourself). The joining stroke up and into the stem involves a pushing movement, unnatural to the pen, which requires a bit of extra practice.

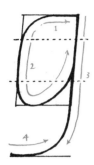 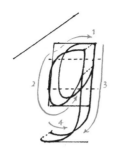

Italic lends itself readily to flourishing on ascenders as well as descenders, but when laying out a piece of work it is always best to use the simplest forms possible and save decorative elements such as flourishes to the very last. In the case of 'g', 'j' and 'u'-based 'y', however, a flourish is an integral part of the letter. A common beginners' mistake is to carry the stem down too far, producing a 'broken' effect; the stem should begin to curve almost as soon as it crosses the line, and stop even before it reaches the thinnest point. The final pulled curve (flattened, not rounded or hooked) is then brought back just to that point, and no further, producing an even, sweeping feel.

Another interchangeable pair: 'p' and 'd'. Do not be tempted to try to eliminate the slight thickening of the joining stroke at the stem; this is a natural result of proper use of the pen and helps produce a smooth transition with little or no 'angled' feel to it. The serif used on the descenders of the alphabet presented in this book are horizontal 'tick' serifs like those used with capitals, but many calligraphers prefer tightly curved serifs to match those of the ascenders.

Arched letters still follow the movement of the 'a'-shape curve, joining or springing from the stem at the same previously determined point. The close relationship between 'n' and 'h' is obvious, both being models of the overhand springing movement which, when performed as a repeated pattern, is a very useful loosening-up exercise.

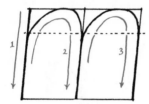 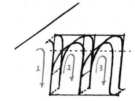

The same warning applies to italic 'm' as to its roman version – do not think of it as a single letter, but as two 'n's, each perhaps slightly under full width, but not much.

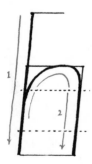 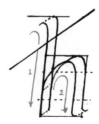

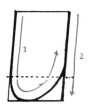 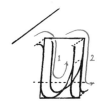

The underhand arched letters: also useful, when done in the form of a repeated pattern, as a loosening-up exercise and as a means of becoming familiar with the awkward but necessary pushed stroke already mentioned. The 'u' should be interchangeable with the 'n' on the previous page.

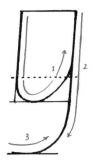 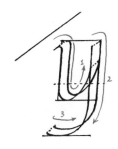

The 'y' can be based on 'u' (as here) or 'v'; the curved descender should be exactly the same as 'g'. The flourish may be open or closed, but should have the same flattened 'snap' in either case.

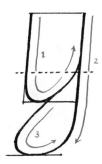 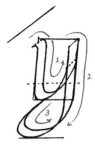

When used on its own within a word, the 'r', like its roman counterpart, consists of the bare beginnings of an 'n', abbreviated as much as possible to avoid the spacing problems it almost inevitably produces. At the end of a line it may be flourished, as below; and when followed by 't', 'i' or 'v' this flourish, much compressed and springing from above the junction line instead of from below it, comes in handy in the reduction of over-wide spacing by means of ligatures.

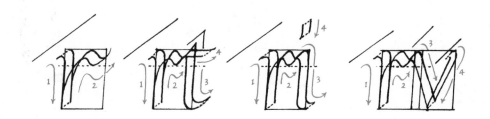

The bowl of the closed 'k' also tends to spring from a higher point on the stem.

 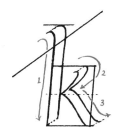

The arm and leg of the 'k', like its capital and minuscule counterparts, merely touch the stem as they join, without entering it. As before, the leg should flourish, not flop, and should not be drawn out too far, except, perhaps, as a small exuberant element at the end of a line.

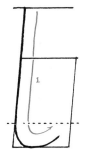 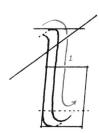

The lower curves of 'l' and 't' are not serifs, but follow the model of the 'a' shape. Remember, though, that the 'l' needs to be straight for almost all its length – do not begin the lower curve too early, or end the curved top serif too late. The cross stroke of 't', like that of 'f', must be under the headline, not on it.

The relationship between 'o' form and 'a' form is a tricky one; they are alike, yet different. An 'o' which follows the shape of an 'a' will lose its balance, whereas an 'a' or 'q' which tries to make itself rigidly elliptical will lose its character. In general, the two can be reconciled to each other by making their vertical curves closely similar, and by slight (preferably invisible) adaptations of form, only learned through practice.

Round 'b' (not included here) is formed by adding an ascender to 'o'. The lower curves of 'e' and 'c' need to follow the 'o' model in order to keep them from looking top-heavy, and producing what one might call an 'overbite'. These are the only rounded letters in the italic alphabet formed on a symmetrical pattern.

This is simply the minuscule form italicized (see 'Italicized Roman Capitals' at the end of this section). Care must be taken to see that an imaginary slanted centre line would cut the 'v'-shaped white space as nearly as possible in half. Beginners tend to make most letters involving diagonal strokes too upright and 'roman'. Note the slightly increased pen-angle.

This form of 'y' is preferred by many for the sake of contrast; however, it can take up more space than it warrants. The curved version can be drawn out as here or quite brief; most useful, however, is the straight-tailed version, since its descender can be lengthened or shortened almost as needed.

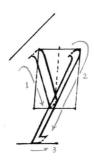
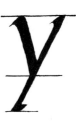

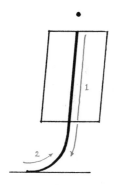 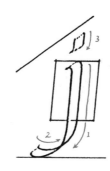

Like the 'g', the 'j' must be flourished.

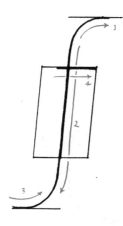 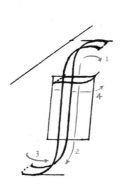

The 'f', on the other hand, can be used in shortened form, which can be most useful in solving line-spacing problems. If you opt for the flourished form, bear in mind that the flourished ascender and the flourished descender are basically the same in form and height – not a short bent hook above and a grand sweeping loop below. The cross stroke, like that of 't', should be just below the headline, and should be noticeably less heavy than the vertical stem.

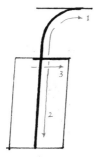 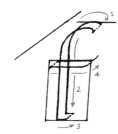

The lower curve of 'i' should be no more than serif size. The dot should be the same height and character as that of 'j'.

The 'w', like the minuscule and capital forms, should be two 'v's, perhaps slightly compressed. The cross stroke of 'x' is slightly serifed here, but often a simple unserifed stroke is quite sufficient, as well as being less fussy. See the 'Italicized Capitals' for a slightly more ornate version.

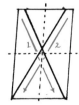 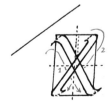

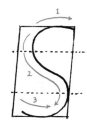 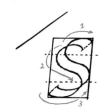

When forming the compressed, italicized form of 's' the narrowing of the form is best brought about by making the central portion of the double curve slightly more horizontal, so that the curve is preserved.

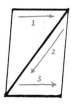

Again, the choice between two forms of 'z': one with a much flattened pen-angle, the other with the angle as usual.

Italicized roman capitals

BRPELFK

These are no more and no less than the Roman capitals learned earlier,

OQCDG

slightly modified for use with the italic alphabet by means of narrowing

SIJHUT

the forms, steepening the pen-angle, and writing them at the same slant

VANMW

as the small letters. Numerals are usually italicized as well.

XY Z

SPACING AND LAYOUT

THE importance of good letter-spacing – the relationship of one letter to another – cannot be over-emphasized. Letterforms may leave much to be desired and still pass muster if they are correctly spaced; but good letters incorrectly spaced are wasted. There are no hard and fast rules – nothing takes the place of a skilled and educated eye – but each script makes its own demands, whose basis can usually be expressed in a few elementary principles. After that, you are on your own.

The spacing of roman capitals demands the most care and foresight; their beautiful forms conceal a whole lurking host of what might be termed 'space-traps'. Even a single word composed of caps requires a certain amount of careful planning; three or four lines, that much more. To give an example: supposing you are required to write out the names of the months, for a calendar. Throughout most of the sequence, with one or two exceptions, the spacing takes care of itself:

JANUARY
FEBRUARY

Then you come to

OCTOBER

The CT combination is a famous space-trap, producing a gaping hole about which nothing can be done, except to go all the way back to the beginning and start again, adjusting the spacing as you go. Moral: do a fairly careful thumbnail sketch before you begin; look for the largest hole; arrange the rest of the spacing to conform to it.

How do you visualize these adjustments? The traditional method is to imagine each letter-space as a container into which (for example) beer is poured. In a well-spaced combination of caps, each container will hold – visually, at least – a similar amount of beer; and the distance between letters varies to allow for this.

Round letters are closest together.

Round and vertical letters are a little further apart.

Vertical letters are furthest apart.

This space between vertical strokes, once determined, becomes the standard of comparison for letter-spacing in any given size and weight of letter used in a single project; it can be very useful to mark it on a paper strip or set a pair of dividers to it, and so have it by you as a means of checking.

Space-traps to watch out for include:

When carried out with proper attention paid to spacing, a text should have an evenness of colour. The reader's eye should be able to take in the words and their meaning without effort, coming up against no obstacles and falling into no holes. Roman minuscules do not present as many problems as capitals in achieving this aim; like other round, horizontally stressed scripts (e.g. Caroline and uncial) the letters enjoy being fairly close together and space-traps are few. A good rule of thumb is to take the space between the legs of an 'n', narrow it slightly and use that as a basis for letter-spacing:

noun

It is possible to close up this spacing even further:

noun

Italic, on the other hand, has a rhythm to it which must be preserved. In this case it is most important that the white spaces (counters) within the letters should be visually equal to the spaces between:

noun

If the letters are extended the spacing must be widened:

noun

If they are compressed the spacing is tightened:

noun

The same holds true of most cursive hands, with a great deal of freedom allowed. Only formal Gothic (textura) preserves a rigidly fixed 'picket fence' pattern in which letter-spacing, counters and pen-strokes are all of equal width:

noun

Spacing between words is generally taken to be somewhat less than the width of an 'o'. The most common beginners' mistake is to make the spaces too wide, so that words tend to be read one by one; it is best to bring words together as close as they will go without actually confusing the reader's eye:

on the ball

Line-spacing (the distance between lines of writing of any given text) depends a great deal, where minuscule letters are concerned, on the length of ascenders and descenders and how near they come to each other. For roman and italic, a distance of three x-heights from baseline to baseline is safe:

Often, however, it is possible to get away with less:

Keep your eye on the ball

Lines of capital and uncial scripts can be much closer, but generally no less than one and one-half x-heights from baseline to baseline, for the sake of legibility:

KEEP YOUR EYE ON THE BALL

Length of line and weight of letter also have considerable influence on line-spacing. Longer lines and lightweight letters demand wider spacing; short lines and heavy letters can be more closely packed. Eight to ten words is a good maximum length for a line, to avoid tiring the reader's eye.

Since there are some people who have never picked
up a pen to write throughout their lives and are
also at a disadvantage, both physically and mentally
like the common mob to which 1 already referred –
they must be made to use two lines to contain
the bodies of their letters,

Since there are
some people
who have never
picked up
a pen to write
throughout
their lives

Since there are some people who have never picked

up a pen to write throughout their lives and are also

at a disadvantage both physically and mentally

Since there are some people who have never picked up a pen to write throughout their lives and are also at a disadvantage, both physically and mentally – like the common mob to which I have already referred – they must be made to use two lines to contain the bodies of their letters.

**Since there are some
people who have never
picked up a pen to write
throughout their lives
and are also
at a disadvantage**

Since there are some people who have never picked up a pen to write throughout their lives and are also at a disadvantage, both physically and

SIGISMONDO FANTI · *Theorica et Pratica*

As emphasized before, the sooner letters and words are *used* instead of 'practised', the better. The basic 'guitar chords' have been provided; they now need to be put together into a tune – a specific project. For the novice lettering craftsman, the prospect is a daunting one, or should be – many important decisions to be made, and all at the same time. What script or scripts should be used; what size, weight and spacing? These depend to a great extent on the layout chosen, which in turn depends on the project itself.

For our purposes, this takes the form of a page layout or broadside, which itself can be one of many things: a favourite poem or quotation, an invitation, greeting, poster or advertisement. At this stage, there are two basic requirements. One: it should be brief (10 to 20 words is plenty). Two: you should have a vested interest in finishing it, working through all the problems to the very end. How this requirement is met is up to you. If you are lucky, or more self-disciplined than most of us, the project you choose will be so pleasurable and absorbing that your own impetus will carry you through. It is wise, however, to choose something which carries its own deadline with it – Christmas, Chanukah, a birthday, or a promise made in a moment of weakness. Whatever you are working on, sooner or later you will inevitably need to take some time away from it, and for this purpose you may have a second project in readiness; but do not go on to a third project until you have finished the first. A project gone into half-heartedly and abandoned halfway through represents a considerable amount of wasted effort.

It should be the nature of the project itself which determines layout and script, not the other way around. To this end, a certain amount of roughing-out work is always necessary, and here is where a close familiarity with letterforms in their skeleton and double-pencil versions comes in very useful. Trying to work out a layout directly with pen and ink from an imagined idea is generally a futile and frustrating business, whereas a pencil rough, so long as it is done carefully enough to give an idea of true weight and spacing, can be used under layout paper as a basis for the next, and so on. Soon the layout should begin to take shape in your mind, and divide itself into various elements; at that point, pen-and-ink versions of these elements can be produced, cut up, moved about and eventually lightly pasted down (preferably with an adhesive which will allow them to be peeled off again when you inevitably change your mind). Note that these cut-up sections should be as few and as complete as possible, and all cut-up work should be done on the same colour paper; difference in paper colour and shadows produced by stuck-on bits and pieces are most distracting to the eye, and make it very difficult to judge a rough layout properly. It is also good policy to consider it now and again from a distance (or through a reducing glass) as well as upside down. Crucial decisions should never be made in a hurry.

Eventually a format will suggest itself – either portrait (vertical) or landscape (horizontal). A poem composed of short verses, for example, will naturally take on a vertical shape. A prose text or quotation, after three or four readings, will usually begin to arrange itself into lines divided by natural pauses, so that the reader takes it in without effort; a horizontal format usually (though not always) proves appropriate in this case. A comic or fanciful greeting gives scope for any number of variations. Display or advertising would depend entirely on what effect was desired. A square format tends to be graceless, and is generally to be avoided.

Margins are important, not least because they prevent you from ever having as much available space as you think you do. (Moral: always work on a far larger sheet of paper than you need.) They should not be so wide that the text of the project 'floats' in the midst of a white sea, but they should be generous enough to supply a border all round, with some extra to allow for mounting and framing. Their proportions can vary enormously according to the shape of the page and the shape and weight of the writing, but almost invariably the foot margin must be wider than the head and sides; a block of writing centred on a page will look too low:

Once format, margins and script have been determined the material may be written out, pasted up and photocopied; these photocopies may then be cut up, line by line, and a second stage embarked upon in which varieties of layout are tried out within the chosen format.

Aligned to the left. The easiest alternative, requiring very little adjustment, with no attempt made at justification to the right; appropriate for much poetry, but not usually successful for prose text (unless lines work out at remarkably similar lengths) since the straight left-hand margin will always look odd compared with the uneven right-hand one. As a starting point, it can be useful to arrange the lines in sequence and see how they compare. A natural next stage would be:

Centred. Find the midpoint of each line of writing, mark it, lay the marks along a vertical centre line, and consider the shape of the resulting text-block. Lay a sheet of layout paper over it and sketch around it. If it seems natural and pleasing, and not too rigidly geometrical, perhaps you need look no further. Usually, however, more experiment is needed, and the result is:

Asymmetrical. Requires a good deal of work and judgement, but can be most rewarding. The layout must have a strong optical centre, or 'backbone', with as even as possible a distribution of weight to each side. The shape of the block of writing should have no hard edges to it:

or 'rivers' within it:

Where titles and names of authors must be included (as with almost all excerpts from prose and poetry) great care is essential – more than one worthy project has foundered because the weight and placing of these two small details was thought unimportant, and left until too late. The following ideas are presented in landscape format, but at least three are applicable to portrait format as well:

When you have determined the final form of your layout and produced a last 'rough' of it, whether photocopied or pasted up, a version must be made with this rough as the basis, on which all spacing – especially of words and letters – must be carefully set out. Line spacing measurements can be transferred by means of dividers set to letter-heights, ascender and descender heights and distance between head and base lines, and 'walked' in the proper sequence down the edge of the paper as described in the 'Methods and Materials' chapter. Alternatively, a 'storyboard' can be made from a strip of stiff paper marked down its edge with the various measurements in their proper sequence, these marks then being carefully transferred to the left edge of the final sheet as a guide for ruling with the T-square. The 'dress rehearsal' version is then written out on these lines, the final rough being held beneath each line as a spacing guide. When done to your satisfaction, this version – or preferably a photocopy of it, so that the original can be kept safe and clean – can be used in its turn as a spacing guide for the final version. By the time that this stage is reached, all problems of spacing and layout should have been worked out to the last detail, so that you can concentrate on the forms of the letters themselves, and need to think of nothing else.

CAROLINE MINUSCULE

THE Caroline minuscule script was the result of the revival of learning of the late 8th and early 9th centuries fostered by Charlemagne (768–814) whose ambition it was to see the standardization of the liturgy, canon law and the monastic mode of life. The evolution of this script was of the utmost significance in the history of the alphabet in Western Europe, for in it can be recognized the embryo of our modern roman lower-case types.

Under the abbacy of Alcuin (see 'A Brief History') the monastery of St. Martin's at Tours was particularly active in the early 9th century in the copying of classical and religious texts and the well-known Grandval Bible (British Library Add. MS 10546) (see illustrations p.17) is a typical product of the period. Our exemplar is a version of the writing from this manuscript, archaic features such as the heavy, clubbed serifs and the long 's' having been replaced by modern variants, and a number of missing letters invented. The round 't' has been given a square alternative.

Caroline minuscule spread to England as a result of the Benedictine revival in the mid-10th century, where it gradually superseded the national Anglo-Saxon hands for the transmission of Latin texts. Here it was developed to a degree of perfection which gave it a character of its own, quite distinct from the continental versions. The Ramsey Psalter (B. L. Harley MS 2904) (see illustration p.18) is a fine example of this English 'formalism' and as noted, provided Edward Johnston with the basis for his 'Foundational Hand'.

The continental Caroline hand was normally written fairly small, and its elegance is somewhat diminished when an attempt is made to render it large scale. In a modern context it is probably most useful as a 'book hand', or at least for work of a small and more intimate nature.

abcdefgh

ijklmnopq

rsttuv

wxyz

N.B. Roman Capitals (see p. 32) may be used effectively with this hand.

Pater noster qui es in coelis; sanctificetur
nomen tuum. Adveniat regnum tuum. Fiat
voluntas tua, sicut in coelo et in terra.
Panem nostrum quotidianum da nobis
hodie. Et dimitte nobis debita nostra

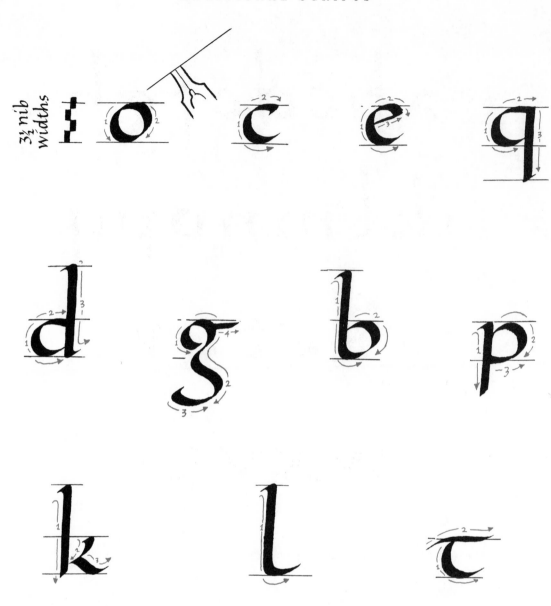

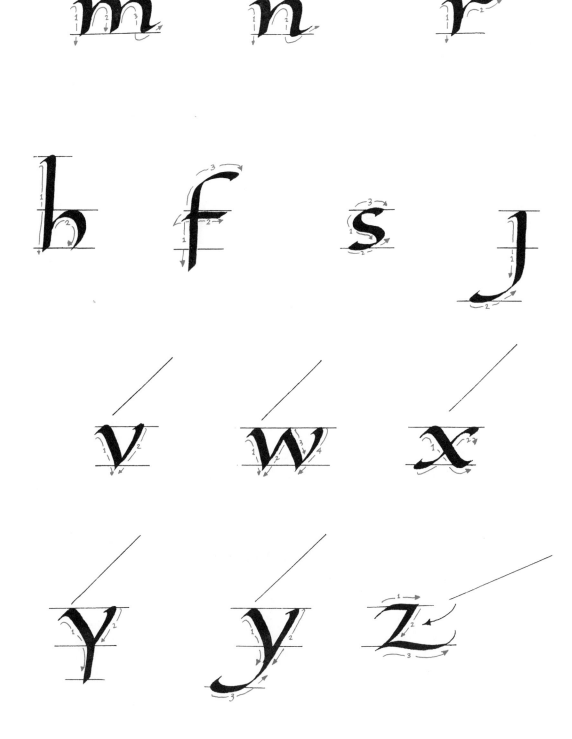

UNCIAL

THE uncial script is generally thought to have originated in Byzantium as the appointed book hand of the early Christian period (early part of the 4th century A.D.), later being adopted throughout the Continent and passing to England as a result of the Roman mission of Pope Gregory the Great. However, recent evidence suggests its genesis to have been earlier, possibly the early 2nd century in North Africa, then a province of Rome.

In uncial we see the emergence of a true 'calligraphic' script rather than pen-made imitations of inscriptional forms, as in Square and Rustic capitals (see 'A Brief History'). The broad-edged pen held at a natural angle has been used to regularize and then modify everyday cursive writing, incorporating elements of the contemporaneous Greek uncial script.

In later examples of uncial, the pen has been flattened to a virtually horizontal position to produce what have been termed 'artificial' uncials, as in the Northumbrian manuscript of the 7th/8th century on page 16. The result of this flat pen-angle is the hairline thinness of the horizontal strokes and relatively heavy weight of other strokes giving a very sharp contrast in the thick and thin 'shading' of the letters. In addition, delicate wedge-shaped serifs occur which are built up with the corner of the nib. To achieve a more comfortable pen hold the nib has probably been cut at a right-oblique angle (see diagram on p. 24).

Uncial is regarded as a majuscule, or capital script, being generally written between two lines. The inter-line space should be roughly two letter heights in a text of average line length to obtain strong bands of writing.

Although it is, of course, an obsolete script, uncial can be used effectively in a modern context, its rounded, dignified forms being particularly suited to the writing out of Latin tracts or ecclesiastical writings.

Ɨ A B C D E F G H I

J K L M N O P Q R

S T U V W X Y Z

PATER NOSTER, QUI ES IN COELIS
SANCTIFICETUR NOMEN TUUM.
ADVENIAT REGNUM TUUM. FIAT
VOLUNTAS TUA, SICUT IN COELO
ET IN TERRA.

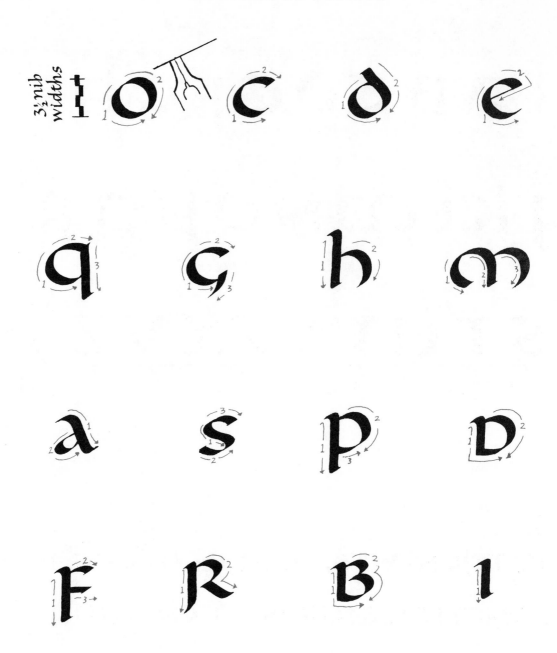

In later 'artificial' uncial scripts, the pen-angle is reduced so that it is virtually horizontal, and the wedge-shaped serifs drawn out with the corner of the nib and then filled in.

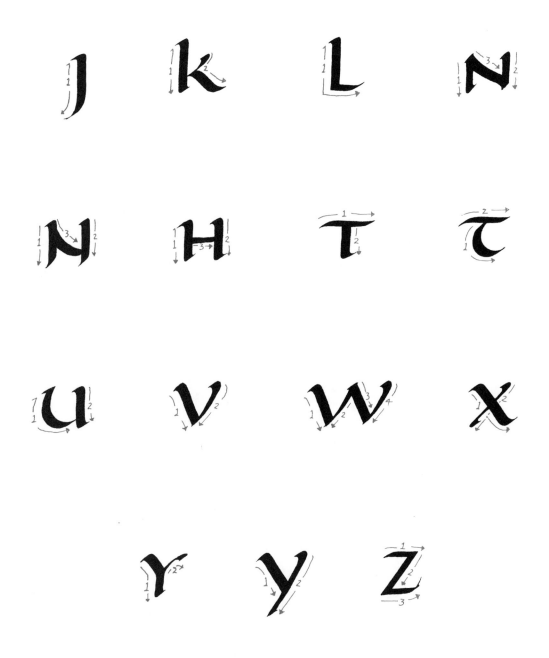

The ideal pen here is a quill with the nib cut at a right-oblique angle.

SILUTAERN

GOTHIC
(TEXTURA)

THE elegant, round and easily read Caroline minuscule remained the pre-eminent international script for nearly four hundred years, but as early as the 11th century, particularly in Belgium and northern France, a gradual change had become discernible in its forms, which had become stiffer and sharper and had lost some of their original harmony. This slow metamorphosis accelerated in the 12th century as letters became more laterally compressed and angular, acquiring odd-shaped serifs such as forks and lozenges.

The Gothic sense of order eventually produced a script where rows of letters are all constructed in the same way, the overall effect being reminiscent of a palisade. Among the many varieties of Gothic, the extreme example of this rigidity is the Textura hand where as uniform an image as possible is achieved by the incidence of exactly equal areas of white space both inside and between letters and points of adjacent lozenge-shaped serifs are allowed to touch each other.

As with all slowly executed, over-deliberate scripts, the formal Gothic book hands were eventually challenged by their cursive derivatives and finally eclipsed in Renaissance scholars' search for a simpler, clearer form of writing which they rediscovered in manuscripts from the Carolingian era.

To modern eyes, Gothic scripts are synonymous with illegibility because of the obvious lack of differentiation in letterform, even though they achieve great aesthetic beauty through unity. Their use today is therefore somewhat limited and it is probably only where special decorative effects are desired that they have a function in life. There may also be occasions where the Gothic spirit needs to be captured in a piece of writing, albeit at the cost of readability.

Iabcdefghijklm
nopqrstuvwxyz

ABCDEFG
KEMNHIJ
OPQRST
UDWXYZ

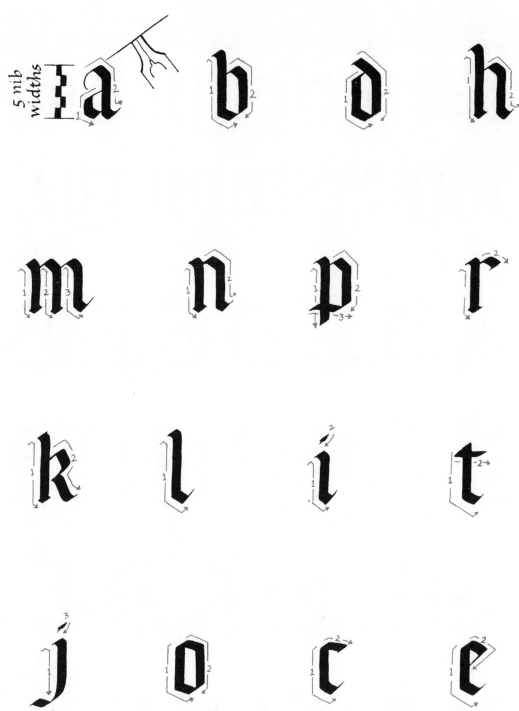

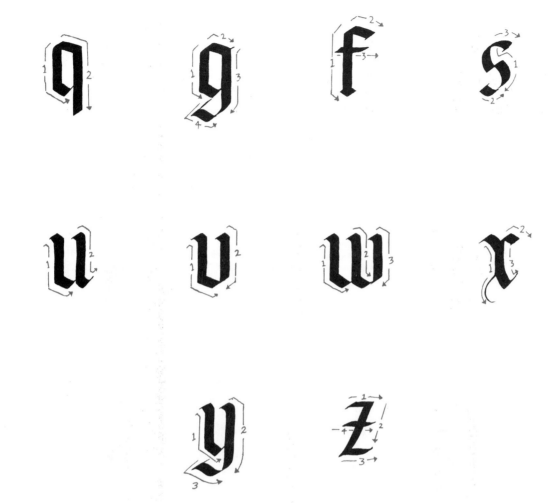

The madnes of dronkennes is so immoderate
That grevous sores it ingendreth and sykenes
It causeth often great foly and debate
With soden deth and carefull hevynes
In thynges no difference putteth dronkennes
It febleth the ioyntis and the body within
Wastynge the brayne makynge the wyt full thyn

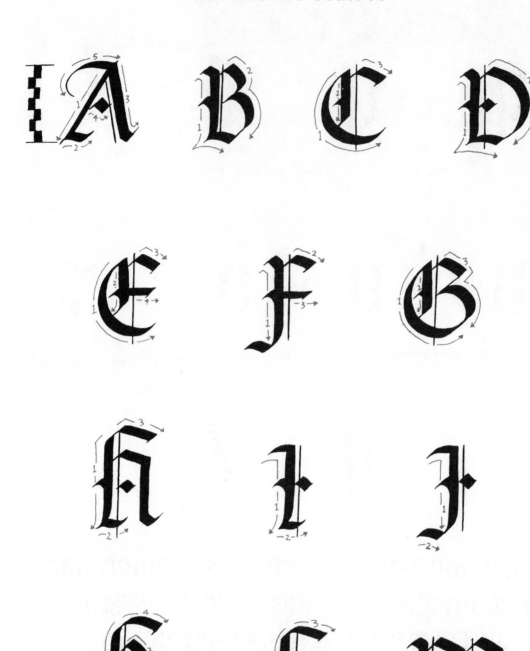

 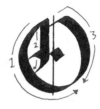

HERALDRY

CALLIGRAPHY literally translated means beautiful writing and as such has traditionally been reserved for the transmission of the most important texts. Even today the most appropriate and therefore most practical use for calligraphy is to be found in such hand-written documents as presentation addresses, freedom scrolls, Patents of Nobility, ecclesiastical service books and memorials, diplomas and certificates and manuscript books. Invariably such work affords the calligrapher an opportunity to introduce heraldry as a decorative feature – an opportunity not to be missed for there is surely no more splendid form of ornamentation than a gorgeous coat-of-arms with its vigorous line, vibrant colour and shimmering gold and silver.

Because heraldry is a precise science with long traditions and a history of regulation by the Crown, a fundamental knowledge of the subject is an essential prerequisite if the designer is to avoid embarrassing errors. Ironically, this knowledge of the rules and traditions can also release him from the tyranny of slavish copying of an existing design which, unless it is an official painting made by the College of Arms, could itself be incorrect in its details and aesthetically unsatisfactory. Just as the calligrapher will take the best of historical scripts for inspiration, perhaps modifying them for contemporary use, so the heraldic designer will need to make an objective study of the best heraldic examples, past and present, in order to give credibility and vitality to his work. Among

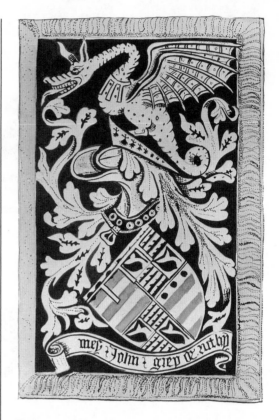

FIGURE 1. *From the stall plate of Sir John Grey of Ruthin (c.1439) in St. George's Chapel, Windsor Castle.*

the finest examples of English heraldry are the earlier of the enamelled stall plates of the Order of the Garter in St. George's Chapel, Windsor Castle, the vigorous line and almost abstract detailing of which can be seen in our example (Fig. 1). The filling of the rectangular space is extremely subtle, with a nice balance of positive and negative elements, and this same balance is achieved with the various devices (or 'charges') in

the shield. The prospective student of heraldic design is urged to make early acquaintance with these splendid pieces of medieval craftsmanship.

After the late Tudor period a marked decline in artistic standards seems to have set in, and the heralds themselves were guilty of perpetrating a somewhat romantic line in the actual devising of the grants. Fortunately, the revival of interest in medieval work towards the second half of the 19th century has led to a resuscitation of these earlier standards and particularly fine work is being produced in our own age.

The amount of published material on matters heraldic is vast, and this very brief discourse can serve only to provide the calligrapher with an awareness of the complexity of the subject. Further reading is suggested in the bibliography towards the back of the book.

The Origins of Heraldry

To understand the origins of heraldry, some definition of the more common terminology may be helpful. First of all, the very word heraldry is frequently misunderstood. Heralds – incidentally they were never equipped with trumpets as is often believed – were originally employed by the King or by great magnates to run verbal and written messages upon the battlefield as well as acting as diplomats and staff officers. In later times they came to control all proceedings at the tournament, acting as a kind of major-domo. These duties required knowledge of the various insignia worn by combatants or identifying enemy factions quickly in the heat of battle. Eventually, the heralds undertook the registration and regulation of these insignia, which had by the mid-12th century become hereditary. They were painted or modelled on to the shield and other trappings, including the linen coat or 'surcoat' which was worn over the chain mail, and from this became known as coats of arms.

The term armory is, in a sense, more appropriate in our context than heraldry, the latter including in addition the multifarious duties of the heralds such as the recording of pedigrees and the organization of functions like the Opening of Parliament and other great ceremonies of state. However, in practice, the two terms have become virtually synonymous.

By the mid-12th century arms had become hereditary; that is to say, a device was handed down from father to son and was therefore unique to one family. Indeed, it was unique to one person, since children of a man bearing arms (an armiger) were required to include in their own arms some mark or other which 'differenced' them. This could be a variant of the same basic design or, at a later date, a system of so-called cadency marks (see Fig. 2) indicating the cadetship within the family. This complex system is now falling into disuse, although in Scotland a much more efficient scheme is central to their heraldic tradition. Naturally, disputes arose in the earliest days when instances occurred of

FIGURE 2. CADENCY MARKS

| Label | Crescent | Mullet | Martlet | Annulet | Fleur-de-lis | Rose |
| Eldest son | 2nd son | 3rd son | 4th son | 5th son | 6th son | 7th son |

two families using the same design of arms, especially since early examples were extremely simple; such matters were later put to the arbitration of the Court of Chivalry.

Many theories have been advanced as to the exact circumstances under which systematized armory developed but a much favoured one is that advances in armour technology, and in particular the advent of the closed helmet, rendered identification on the field difficult. This took on a new significance at the time of the second Crusades when warriors from all corners of Europe took up arms against the infidel. The shield was always the central element of a coat of arms but eventually every available surface was emblazoned with the particular device of the person concerned (see Fig. 3). Further assistance in identi-

FIGURE 3. *The advances in the design of armour, and in particular the closed helmet, made personal identification on the field of battle difficult. A knight's coat of arms is here displayed on shield, banner, horse trapper scabbard, epaulettes and saddle. Crest and mantling complete the complex heraldic display.*

fication was made possible by the fixing of a crest on top of the helmet, originally a simple fan shape but later fashioned to represent naturalistic items such as an animal's head, a bird, feathers, and so on. Incidentally the crest is another indication of the confusion in some people's minds when it comes to heraldic nomenclature – the term is often used mistakenly for the coat of arms itself. The strip of cloth seen around the helmet and known as the mantling was placed there to protect the metal from the effects of the elements and was held in position by a skein of twisted silk called the torse or wreath.

The granting of coats of arms to individuals and later to corporate bodies eventually came under the aegis of the College of Arms, which was incorporated by Richard III in 1484 and survives in largely unaltered form today, a survival unique in world heraldry. As representative of the monarch, the Earl Marshal – an office traditionally occupied by the Duke of Norfolk – presides over the College whose executive officers are: the three Kings of Arms, Garter, Clarenceux and Norroy & Ulster; six heralds, Richmond, Lancaster, Chester, Windsor, Somerset and York; and four pursuivants with the delightful titles Bluemantle, Rouge Croix, Rouge Dragon and Portcullis. Heralds extraordinary are appointed from time to time. With the number of new grants today totalling just over 200 a year, interest in heraldry is as intense as at any time in recent history.

What is a Coat of Arms?

After the demise of heraldry in its purely practical role, on the battlefield and at the tournament, it retained a function in its graphic form as a means of ornament and decoration. Opportunities for the display of heraldic emblems are very wide ranging.

Marshalling of Arms – Man and Wife

If an armiger marries a lady from an armigerous family, he impales his own arms with hers, his on the dexter side of the shield and hers on the sinister. However, if the lady happens to be an heraldic heiress, meaning that all the male members of her family have died, her arms are placed on an escutcheon of pretence in the centre of the shield as her husband pretends to the representation of her family.

The son of an heraldic heiress is allowed to quarter his father's and mother's arms, his father's being in the first and fourth quarters and his mother's in the second and third. If the son marries a girl from an armigerous family he places his quartered arms on the left beside hers on the right. If she is an heraldic heiress she will place her arms in an escutcheon of pretence on top of her husband's quarterings.

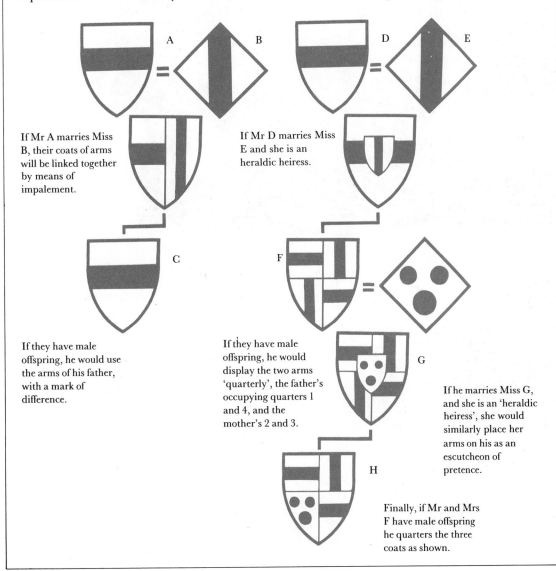

If Mr A marries Miss B, their coats of arms will be linked together by means of impalement.

If they have male offspring, he would use the arms of his father, with a mark of difference.

If Mr D marries Miss E and she is an heraldic heiress.

If they have male offspring, he would display the two arms 'quarterly', the father's occupying quarters 1 and 4, and the mother's 2 and 3.

If he marries Miss G, and she is an 'heraldic heiress', she would similarly place her arms on his as an escutcheon of pretence.

Finally, if Mr and Mrs F have male offspring he quarters the three coats as shown.

FIGURE 4. *An example of the full achievement of arms of a peer. From a painting based on the hatchment (funeral achievement) of the 2nd Earl of Guilford (known as Lord North) in Kirtling Church, Cambridgeshire.*

N.B. The small coat of arms in the centre, on an escutcheon of pretence (see below, are those of his wife Anne Speke. The encircling of the combined husband/wife arms with the circlet of an order of chivalry (in this case the Garter) is unusual.

KEY

1. Crest
2. Torse or Wreath
3. Mantling
4. Supporters
5. Compartment
6. Motto
7. Shield or Escutcheon
8. Helm
9. Coronet
10. Circlet

Obvious examples are heraldic manuscripts, stained glass, porcelain, silverware, textiles as well as architectural applications on gateways, buildings and the like. Figure 4 shows a complex arrangement of several components collectively known as an 'achievement of arms'; they are the arms of a peer of the realm, the 2nd Earl of Guilford (Lord North) who held office as Prime Minister from 1770 to 1782.

Component parts of an achievement of arms:

SHIELD: The shield is the most important part of the achievement. In fact, a coat of arms may consist solely of the shield, all other items being accessory to it.

CREST: This was securely fixed to the helmet ('helm' in heraldic parlance) and was sometimes intricately fashioned out of wood or boiled leather.

HELM AND MANTLING: These are not normally specified in a grant of arms but may be added to an achievement at discretion provided a crest is included. The design of the helm is indicative of the rank or degree of the bearer, the five ranks of the peerage being further identified by the placing of the appropriate coronet above the shield (see Fig. 6). Baronets, who employ the open-visored helm of the Knightage, additionally place the badge of Ulster (English and U.K. baronets) or of Nova Scotia (Scottish) upon the shield. Betokening the fact, however, that no rule or convention is absolutely sacrosanct, a recent grant to a former R.A.F. Squadron Leader allows the use of a modern pilot's helmet for the first time in heraldry!

Mantling is often depicted with jagged edges representing sword thrusts in battle, and in its flowing design the artist may

FIGURE 6. *Coronets and Helms are often included in an 'Achievement of Arms'. Different types denote the different ranks of the peerage.*

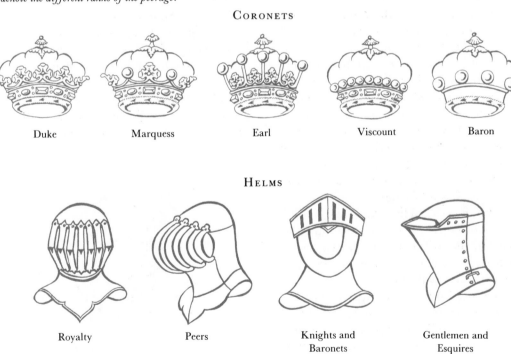

CORONETS

| Duke | Marquess | Earl | Viscount | Baron |

HELMS

| Royalty | Peers | Knights and Baronets | Gentlemen and Esquires |

exercise a great deal of licence. Apart from a period when all mantling was rendered in red and silver, the colouring has normally been that of the main colour and metal or fur in the arms. Again a relaxation of these rules is occurring with a return to the varied colours of medieval practice.

TORSE, OR WREATH: This skein of twisted silk holds the mantling in position and hides the join between helm and crest. There is a convention which allows six twists to be shown, starting on the left with the main metal in the arms, then colour, metal, colour, metal, colour. Again, this has varied in the past and once comprised the so-called livery colours (the 'household' colours). Occasionally, the torse is replaced by a *chapeau* (cap of maintenance) or by coronets and crowns that are not indicative of rank.

SUPPORTERS: The origins of the use of supporters, normally a pair of ferocious-looking beasts symbolizing protection of the arms, is somewhat obscure, but may have been the result of the whimsy of early seal engravers whose dislike of unused space within the restrictions of the circular format of the seal led to the filling of these gaps with mythical beasts and the like. The practice became officially accepted, but in England, at any rate, supporters are restricted to Royalty, peers, knights attached to Orders of Chivalry, and major corporate bodies. Dispensations have occurred from time to time but would be pursuant only to a grant by Royal Warrant.

COMPARTMENT: The compartment is not always included in a grant but may be added by the artist to provide a base for the supporters. A grassy mount is the usual way of dealing with this.

MOTTO: Like the compartment, the motto or *cri-de-guerre* is not necessarily provided for in the grant of arms but may be adopted at will by the armiger. It is usually couched in Latin or Anglo-Norman and displayed on its scroll below the shield. The opposite applies in Scotland, where its normal position is above the whole achievement. No convention exists for the colouring of the motto lettering and scroll, which is entirely discretionary.

ESCUTCHEON OF PRETENCE: The arms of Lord North's wife, Anne Speke, are placed centrally on an inescutcheon indicating that she was an heraldic heiress, that is to say, all male members of her family have died and therefore the 2nd Earl pretends to the representation of that family.

ORDER OF THE GARTER: Members of the various Orders of Chivalry are entitled to encircle their shield with the circlet of that Order. Lord North was made a Knight of the Most Noble Order of the Garter, the senior surviving Order, dating back to the reign of Edward III, and the well-known Garter ribbon with its motto '*Honi soit qui mal y pense*' is seen here around the shield.

BADGE: Another heraldic accessory whose origin is the subject of much debate is the badge, since its use in former times was more or less informal and may even pre-date the use of arms. Despite this, the heraldic badge as we know it came into use about the time of Edward III. As we have seen, arms are hereditary and as such

FIGURE 7. *Stafford Knot Badge.*

unique to one person. Non-armigerous retainers of a great lord rendering feudal service would obviously be debarred from carrying the arms of their master, but were permitted to display his badge as the mark of allegiance.

Typical heraldic badges are the broom plant (*planta genista*) of the Plantagenets, the red rose of the Lancaster family, the white rose of the Yorkists and the well-known Stafford knot of the Earls of Stafford (Figure 7). The badge was often displayed on a roundel of the livery colours. After a relatively long period of disuse, the badge is now beginning to come back into fashion and is included in many modern grants.

Some Design Aspects of a Coat of Arms

THE SHIELD

While there have been conventions of fashion as far as the form of the shield is concerned, in reality there is no restriction and the artist has a reasonably free rein in this area. However, there is one exception, the lozenge being reserved for the arms of ladies. Apart from this, arms, as well as being incorporated into the more conventional shield shapes, may be displayed on a square, rectangle, oval or indeed any shape the imagination may care to conjure up. An early pattern (12th/13th centuries) for armorial purposes was the heater shape, so

SHIELD SHAPES

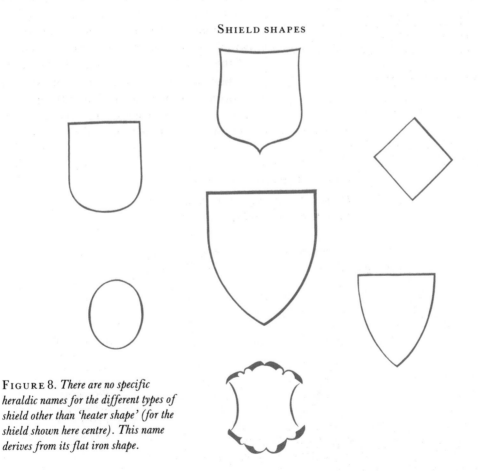

FIGURE 8. *There are no specific heraldic names for the different types of shield other than 'heater shape' (for the shield shown here centre). This name derives from its flat iron shape.*

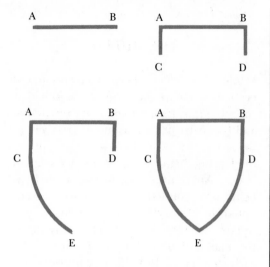

FIGURE 9. HOW TO CONSTRUCT A SHIELD

1. Draw top line A – B
2. Drop perpendiculars at A and B to give C and D. Make A – C and B – D 1/3rd of length of A – B.
3. With radius C – D, place compass point at C and describe an arc C – E.
4. Reverse the process to give D – E.

called after its resemblance to a flat iron, and this remains the most elegant of shields (see Fig. 8). A simple method of construction is shown (see Fig. 9) – other more complex types are best made by drawing one half, then tracing it to form the other half to get a symmetrical design.

Tinctures and Furs

The colours employed in heraldry are relatively few, the principal ones being shown here (see Fig. 12) with their heraldic terms and in the dot and line system occasionally used to depict arms in the medium of black-and-white (Sancta Petra system).

There are also two metals (gold and silver) for which the colours yellow and white/grey may be substituted, and a combination of furs, the most common of which are ermine (said to represent the fur of the stoat); and vair (squirrel). Heraldic colours are always vibrant for maximum visibility on the battlefield, and the general rule is that a colour must be used in conjunction with a metal, or vice versa.

FIGURE 10. PARTS OF THE SHIELD

The right- and left-hand sides of the shield are as they appear to the bearer, and not the viewer.

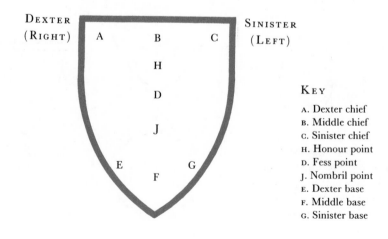

KEY

A. Dexter chief
B. Middle chief
C. Sinister chief
H. Honour point
D. Fess point
J. Nombril point
E. Dexter base
F. Middle base
G. Sinister base

FIGURE 11. *The bold tinctures used in heraldry derive from the need for maximum visibility on the field of battle.*

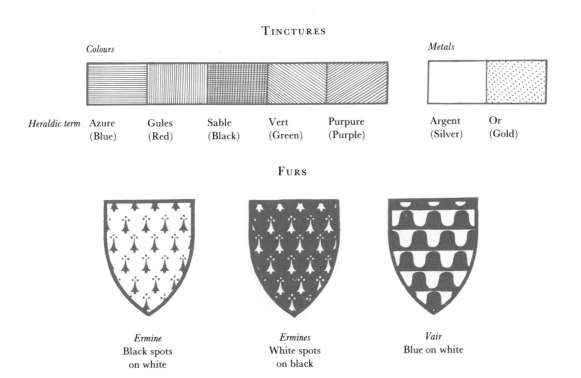

TINCTURES

Colours *Metals*

Heraldic term	Azure (Blue)	Gules (Red)	Sable (Black)	Vert (Green)	Purpure (Purple)	Argent (Silver)	Or (Gold)

FURS

Ermine Black spots on white	Ermines White spots on black	Vair Blue on white

THE FIELD

The basic tincture of the shield is known as the 'field' and can be either a single colour, metal or fur, or it may be parti-coloured when the shield is divided up into geometric portions by partition lines (see Fig. 12) and referred to as a parted field or a varied field.

The written description (or blazon) in the case of a field could be simply, for example, 'Gules' and instances have occurred where this single-word blazon constitutes the complete coat of arms, no other elements being added. Parted fields, however, are described in one of three ways, 'party per . . .', 'parted per . . .' or simply 'per . . .' Party per fess argent and gules would describe the field of No. 2 on page 110; the field is divided horizontally

FIGURE 12. DECORATIVE PARTITION LINES
Lines used to divide a shield into parts are normally plain but may be ornamental. The more usual forms are:

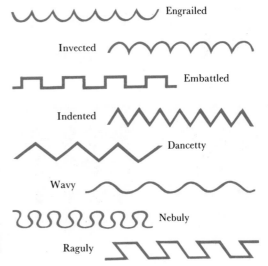

Engrailed

Invected

Embattled

Indented

Dancetty

Wavy

Nebuly

Raguly

FIGURE 13. *The basic colour of the shield is called 'The field'. When the shield is parti-coloured and divided by partition lines into geometric portions this is known as a parted field. Varied fields are more complex versions of parted fields.*

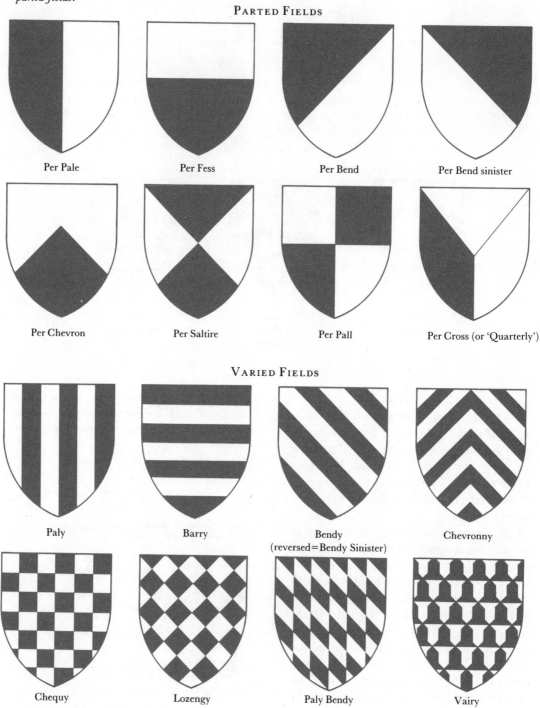

PARTED FIELDS

Per Pale Per Fess Per Bend Per Bend sinister

Per Chevron Per Saltire Per Pall Per Cross (or 'Quarterly')

VARIED FIELDS

Paly Barry Bendy
(reversed=Bendy Sinister) Chevronny

Chequy Lozengy Paly Bendy Vairy

FIGURE 14. *The Honourable Ordinaries were the earliest type of 'charges' and are composed largely of rectilinear bands. The field is always the dominant colour and thus the 'charge' always appears to have been placed upon it.*

THE HONOURABLE ORDINARIES.

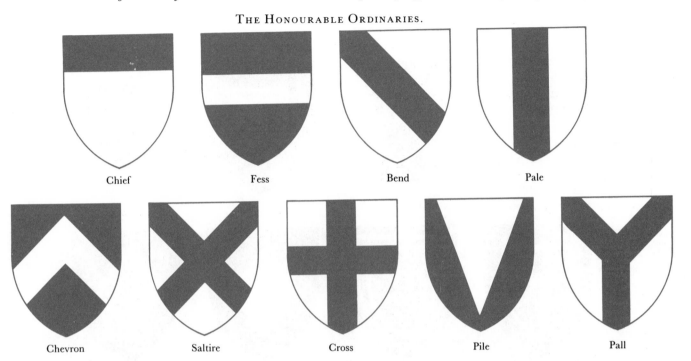

into roughly equal halves, the top half being silver and the bottom red.

Varied fields (see Fig. 13) are more complex versions of divided fields and may be described in a single word such as Paly, Bendy, Barry, and so on, or sometimes by combinations such as Barry Bendy.

CHARGES

Objects placed upon the field are known as charges and range from simple geometric shapes through animals, plants and other natural phenomena to man-made objects – the 40-foot reflecting telescope incorporated into the arms of Sir William Herschel, and the railway locomotive which adorns those of the town of Swindon being more esoteric examples.

THE HONOURABLE ORDINARIES: The earliest heraldic devices (see Fig. 14) were

extremely simple in design, being largely composed of rectilinear bands. These hold a special position in the heraldic hierarchy and carry the label Honourable Ordinaries, or simply Ordinaries.

Much controversy rages over the classification of ordinaries and the lesser subordinaries. The point to remember is that, as with all charges, they are affixed to the field, therefore partially obscuring it.

FIGURE 15. *Varied Field (left), Varied Field With Charge (right).*

FIGURE 16. *The Sub Ordinary charges are again of simple design and next in importance to the Honourable Ordinaries.*

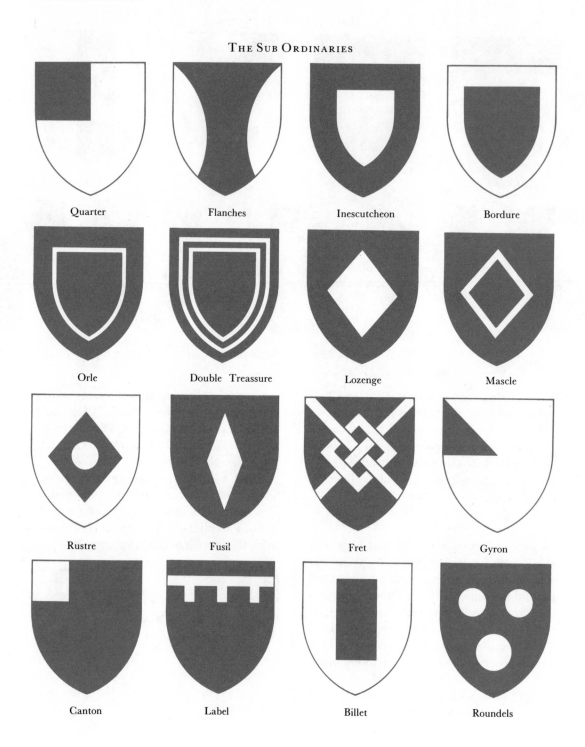

THE SUB ORDINARIES

Quarter Flanches Inescutcheon Bordure

Orle Double Treassure Lozenge Mascle

Rustre Fusil Fret Gyron

Canton Label Billet Roundels

Writers in former times have laid down rules for the proportions of ordinaries, but in practice a certain amount of latitude is allowed the artist, especially in instances where other charges are placed upon or between them. A number of ordinaries have what are termed 'diminutives', that is to say narrower versions displayed in multiple. The following is a list of these ordinaries and their diminutives:

Ordinary	*Diminutive*
Fess	Bars, Barrulets
Pale	Pallets
Bend	Bendlets
Bend Sinister	Bendlets Sinister
Chevron	Chevronels
	or Couple-Close

THE SUB-ORDINARIES: Next in importance are the Sub-Ordinaries, which are again of simple design (see Fig. 16).

One or two of the sub-ordinaries have a specific function, such as the canton which is frequently reserved for the bearing of marks of 'augmentation', these being an additional device awarded by the monarch for meritorious deeds such as victory in a major battle. An instance of this is the canton of St. George awarded to the first Sir Winston Churchill, by Charles I, and Charles II's granting of a 'canton of England' to Jane Lane for her part in his escape after the Battle of Worcester.

Similarly, the bordure (usually itself charged) can occur as a mark of illegitimacy

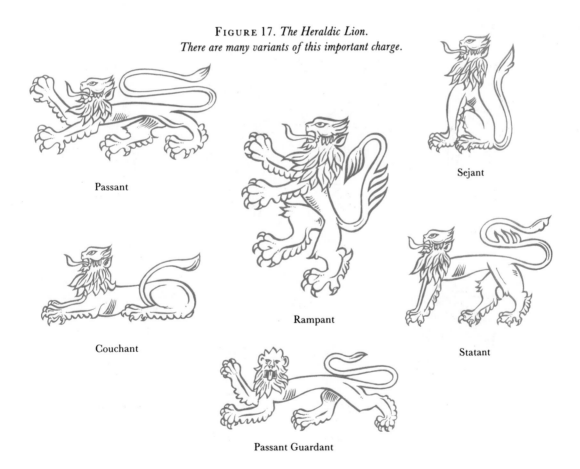

FIGURE 17. *The Heraldic Lion.*
There are many variants of this important charge.

Passant

Sejant

Couchant

Rampant

Statant

Passant Guardant

or in Scotland as part of the differentiating scheme for cadency, while the inescutcheon is used to display the arms of a wife who also happens to be an heraldic heiress (see Marshalling of Arms – Man and Wife), when it becomes known as an Escutcheon of Pretence.

OTHER CHARGES: There would appear to be no limit on the possibilities for using animals, flora and fauna, symbols and objects as charges (see Fig. 18), but no further classification has ever been deemed necessary to categorize them even though,

in England, the lion (see Fig. 17) has undisputed dominance over the rest of the heraldic animal kingdom. The earliest depiction of the lion was in its upright position, but the addition of the adjective 'rampant' became necessary when other leonine stances were introduced (see Fig. 17).

HERALDIC LANGUAGE AND BLAZON

Many attempts have been made to modernize the Anglo-Norman language of heraldry with only limited success, English,

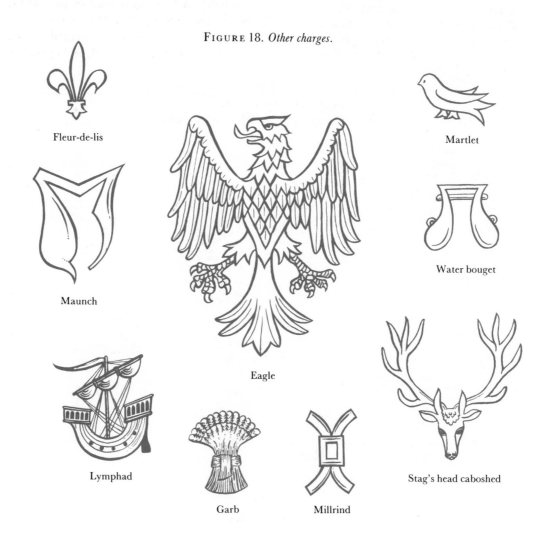

FIGURE 18. *Other charges.*

Fleur-de-lis

Maunch

Lymphad

Garb

Eagle

Millrind

Martlet

Water bouget

Stag's head caboshed

more often than not, providing only an extended and clumsily wordy alternative. For instance, how much simpler it is to describe a 'bend sinister', thus than as 'a narrow band running from the top right-hand corner of the shield to a point on the left-hand side somewhere between centre and base'.

The term 'blazon' is simply the written description of a coat of arms. There is an accepted sequence in blazoning which makes for a delightfully efficient system which, once it has been mastered, is incapable of misinterpretation. Simply expressed, this is as follows: First, the field is named by mentioning its tincture. Next, the principal charge or ordinary is specified with tincture and any other special features. Lesser charges follow with an indication of their positioning, colour, and so on. Following these come charges situated on the ordinary, again with position and colour stated. Quite frequently, all the designer of a coat of arms has to work from is the blazon – so an accurate translation is vitally important.

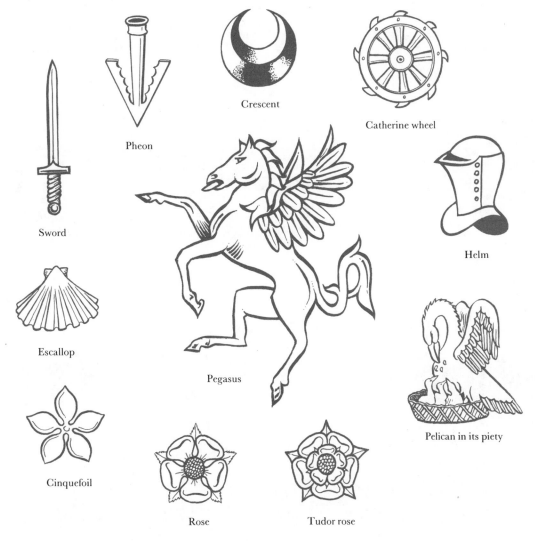

Pheon

Crescent

Catherine wheel

Sword

Helm

Escallop

Pegasus

Pelican in its piety

Cinquefoil

Rose

Tudor rose

The boast of heraldry, the pomp of pow'r

GRAY'S 'ELEGY'

Heraldry, or armory, is medieval in origin and is concerned with identification. It was originally a way of distinguishing armoured warriors on the battlefield by means of hereditary devices placed upon a shield, a system which developed at about the time of the first Crusades in the mid-twelfth century. Marks had appeared on shields long before this but now they became hereditary and subject to control by the heralds.

Apart from individuals, heralds also granted coats of arms to public bodies, corporations, cities, colleges, schools etc. In the case of the Cambridge colleges the arms are frequently those of the founder or dedicatee with the addition of some distinguishing mark. For instance, Churchill College has adopted the arms of Sir Winston Churchill with the addition of an open book in the centre of the shield whilst Fitzwilliam has a combination of those of the Fitzwilliam family (red and white lozenges) and Cambridge University (four golden lions on a red background and an ermine cross with a gilt-clasped book). Canting arms are those which allude to their owners' name by means of a visual pun, those of Jesus College are an example, having three cocks as a pun on the name of the founder Bishop Alcock.

On a tour of the colleges hundreds of examples of fine heraldry are to be found in many media, from carved varieties (those on St John's and Christ's Colleges Gateways are among the finest in the country) to stained glass, painted and engraved ones too numerous to mention.

AN HERALDIC MAP OF CAMBRIDGE

PETERHOUSE · CLARE · PEMBROKE · GONVILLE & CAIUS · TRINITY HALL

RIDLEY HALL · ROBINSON · HOMERTON · LUCY CAVENDISH

HUGHES HALL · CLARE HALL · WOLFSON · DARWIN · NEW HALL · CHURCHILL

CORPUS CHRISTI · KINGS · QUEENS' · ST. CATHARINE'S · JESUS

CHRIST'S · ST. JOHN'S

MAGDALENE

TRINITY

EMMANUEL

SIDNEY SUSSEX

...OF · FITZWILLIAM · SELWYN · NEWNHAM · GIRTON · DOWNING

CAMBRIDGE

KEY

1 PETERHOUSE
2 CLARE
3 PEMBROKE
4 GONVILLE & CAIUS
5 TRINITY HALL
6 CORPUS CHRISTI
7 KINGS
8 QUEENS
9 ST CATHARINES
10 JESUS
11 CHRISTS
12 ST JOHNS
13 MAGDALENE
14 TRINITY
15 EMMANUEL
16 SIDNEY SUSSEX
17 DOWNING
18 NEWNHAM
19 SELWYN
20 CHURCHILL
21 DARWIN
22 CLARE HALL
23 LUCY CAVENDISH
24 ROBINSON
25 RIDLEY HALL

SCALE

MILES ¼ ½

© Calligraphic Enterprises, Cambridge
Printed at The Cloister Press, Cambridge
CALLIGRAPHY HERALDRY DESIGN BY GERALD FLEUSS & PATRICIA GIDNEY

Jesus Green
RIVER CAM
VICTORIA AVENUE
Midsummer Common
NEWMARKET RD
MAIDS CAUSEWAY
JESUS LANE
KING STREET
NEW SQUARE
FITZROY ST
CLARENDON STREET
PARKER ST
PARKSIDE
GONVILLE PLACE
REGENT ST
Parker's Piece
ST. ANDREWS STREET
EMMANUEL ST
Christs
Pieces
SIDNEY STREET
Hughes Hall

This decorative map of Cambridge, the work of Gerald Fleuss and Patricia Gidney, not only shows an interesting fusion of heraldry and calligraphy but serves to illustrate a number of points of heraldic practice. The border consists of the arms of most of the Cambridge colleges arranged in a clockwise chronological sequence relating to the date of grant (with the addition of Ridley Hall, a theological college). The arms of the City form the centrepiece and those of the University are included at the bottom.

PETERHOUSE: Or, four pallets and a bordure gules charged with three crowns or arms of the founder Hugh de Balsham, Bishop of Ely, with a bordure of the See of Ely.

CLARE: Or, three chevrons gules (Clare) impaling Or a cross gules (De Burgh); all within a bordure sable goutty d'or. Arms of the foundress, Elizabeth, Lady of Clare and her first husband, her arms unusually occupying the dexter side of the shield.

PEMBROKE: Barry of ten argent and azure, an orle of martlets gules (De Valence) dimidiating Gules, three pallets vair on a chief or, a label of five points azure (De St. Pol). Arms of the foundress, Mary de St. Pol, Countess of Pembroke. A rare example of dimidiated arms, that is to say, the two arms are each cut down the middle and linked to form the whole.

GONVILLE & CAIUS: Argent, on a chevron between two couple closes indented sable three escallops or (Gonville) impaling Or, a semé of flowers gentle, in the middle of the chief a sengrene resting upon the heads of two serpents in pale, their tails knit together, all in proper colour, resting upon a square marble stone vert, between their breasts a book sable garnished gules, buckles or (Caius); all within a bordure compony argent and sable. Founder's arms.

TRINITY HALL: Sable, a crescent within a bordure ermine. Differenced arms of the founder, Bishop Bateman.

CORPUS CHRISTI: Quarterly 1 and 4, Gules, a pelican in its piety argent; 2 and 3, Azure, three lily flowers argent. Signifying the two founding guilds.

KING'S: Sable, three roses argent, a chief per pale azure and gules charged on the dexter side with a fleur-de-lis and on the sinister with a lion passant guardant d'or. Lion and fleur-de-lis signifying the kingdoms of England and France, the black field signifying stability and the roses 'redolent of every kind of knowledge to the honour and devout worship of Almighty God, and the Spotless Virgin and glorious Mother . . .'.

QUEENS': Quarterly of six: 1, Barry of eight argent and gules (Hungary). 2, Azure, semé of fleurs-de-lis or, a label of three points gules (Naples). 3, Argent, a cross potent between four crosses crosslet potent or (Jerusalem). 4, Azure, semé of fleurs-de-lis or, a bordure gules (Anjou Modern). 5, Azure semé of crosses crosslets fitché, two barbels haurient addorsed or (Bar). 6, Or, on a bend gules three alerions displayed argent (Lorraine) all within a bordure vert. Differenced arms of the co-foundress, Margaret of Anjou, wife of Henry VI.

ST. CATHARINE'S: Gules, a Catherine Wheel or (St. Catharine). Arms of St. Catharine of Alexandria, patroness of learning.

JESUS: Argent, a fess between three cocks' heads erased sable, combed and wattled gules within a bordure gules semé of crowns or. Arms of Bishop Alcock with bordure of the See of Ely. An example of 'canting' or 'punning' arms, that is, a visual pun on the name.

CHRIST'S ST. JOHN'S: Quarterly 1 and 4, Azure, three fleurs-de-lis or (France Modern); 2 and 3, Gules, three lions passant in pale or (England); all within a bordure compony argent and azure. Arms of Lady Margaret Beaufort, Countess of Richmond and Derby, mother of Henry VII and foundress of both colleges. The bordure as a mark of illegitimacy, the Beaufort family deriving from the union of John of Gaunt, son of Edward III, and Catherine Swynford. They later married and the children were legitimated.

MAGDALENE: Quarterly per pale indented or and azure, in the second and third quarters an eagle displayed or, over all on a bend azure a fret between two martlets or. Arms of the founder, Thomas Lord Audley of Walden.

TRINITY: Argent, a chevron between three roses gules barbed and seeded proper and on a chief gules a lion passant guardant between two closed books all or. The lion alludes to the founder, Henry VIII.

EMMANUEL: Argent, a lion rampant azure langued and armed gules, holding in its dexter paw a wreath of laurel proper, and issuing from its mouth a scroll charged with the word 'Emmanuel'. The lion is taken from the arms of Sir Walter Mildmay, the founder.

SIDNEY SUSSEX: Argent, a bend engrailed sable (Radcliffe) impaling Or, a pheon azure (Sidney). Arms of the foundress, Lady Frances Sidney, Countess of Sussex.

DOWNING: Barry of eight argent and vert, a griffin segreant or within a bordure azure charged with eight roses of the first seeded and barbed proper. Arms of the founder, Sir George Downing, differenced by a blue bordure with white roses.

GIRTON: Quarterly vert and argent, a cross flory counterchanged between in the first and fourth quarters a roundel ermine and in the second and third quarters a crescent gules. Taken from the arms of the four people principally concerned with the founding of the college.

NEWNHAM: Argent, on a chevron azure between in chief two crosses bottonné fitché and in base a mullet sable, a griffin's head erased or between two mascles of the field. Taken from arms of those principally concerned in the founding of the college.

SELWYN: Per pale gules and argent, a cross potent quadrate argent and or between four crosses paty, those to the dexter argent, those to the sinister or (See of Lichfield) impaling Argent on a

bend cotised sable three annulets or (Selwyn) all within a bordure sable. College founded as memorial to Bishop Selwyn of Lichfield.

FITZWILLIAM: Lozengy argent and gules, a chief of the University of Cambridge. Arms of the patron, Earl Fitzwilliam.

CHURCHILL: Quarterly 1 and 4, Sable, a lion rampant argent, on a canton of the last a cross gules 2 and 3, quarterly argent and gules, in the second and third quarters a fret or, on a bend sable three escallops also argent; over all in the fess point an open book likewise argent. Arms of Sir Winston Churchill, to whom the college has been made a memorial. The open book is a mark of difference.

NEW HALL: Sable, a dolphin palewise, head downwards to the dexter, in chief three mullets fesswise, a bordure embattled argent. The mullets are from the arms of the first president and the dolphin is symbolic of learning.

DARWIN: Argent, on a bend gules cotised vert between two mullets each within an annulet gules three escallops or (Darwin) impaling per fess dancetty azure and gules, a caduceus between in chief two roses or (Rayne) all within a bordure or. Arms of the principal benefactors within a gold bordure.

WOLFSON: Ermine, a chevron gules between in chief two lions passant guardant or and in base a handbell proper. The lions and ermine are from the arms of the University and the handbell from those of the Wolfson family, the major benefaction coming from the Wolfson Foundation.

CLARE HALL: Chevronny or and gules, on a chief sable five gouttes three and two argent. From the arms of the parent Clare College.

HUGHES HALL: Per fess gules and ermine, a pale counterchanged in the gules in chief two owls the dexter contourné and in base a torch erect or enflamed proper. The owls and torch symbolize learning.

LUCY CAVENDISH: Per fess enarched azure and sable, in chief two bars wavy argent, over all issuant from the fess line a water lily also argent slipped and leaved vert, and in base a buck's head caboshed, between the attires, a lozenge argent charged with an escallop sable. The buck's head is from the arms of the Cavendish family, after whom the college was named.

HOMERTON: Argent, a leopard's face jessant-de-lis sable between three griffins' heads erased gules, on a bordure azure, eight open books proper. Arms of the co-founder with a bordure for difference.

ROBINSON: Azure, in base two bars wavy argent over all a Pegasus rampant or gorged with a crown rayonné gules.

RIDLEY HALL: Party per pale gules and argent, on the dexter two swords in saltire points upwards proper, hilt and pommel or, and on the sinister in chief a bull passant of the first and in base a rush plant flowered and eradicated also proper, the whole within a bordure ermine.

UNIVERSITY OF CAMBRIDGE: Gules, a cross ermine between four lions passant guardant or, and on the cross a closed book fessways gules clasped and garnished gold, the clasps downward.

CITY OF CAMBRIDGE: Gules, a bridge, in chief a fleur-de-lis or between two roses argent, and in base barry wavy argent and azure, three lymphads sable. Crest: Upon a wreath or and gules, on a mount vert a bridge argent; mantled gules doubled argent. Supporters: Two Neptune's horses, the upper part gules, the nether part proper finned gold. The nautical elements in these arms are indicative of the erstwhile maritime trade of Cambridge.

GLOSSARY

Alerion: Eagle without beak or legs
Annulet: A ring
Attires: The antlers of a stag
Barbed: Having barbs
Caboshed: Cut off with no part of neck showing
Caduceus: The staff of Mercury, made up of a ball-headed rod, winged and entwined by two serpents
Combed and wattled: Refers to a cock's comb and wattles
Contourny (or Contourné): Facing to the sinister
Cotised: When a bend is edged by two narrow bendlets
Counterchanged: Tinctures reversed
Couple-closes: Narrow chevronels enclosing a chevron
Cross botonny (or botonné): A cross with each limb ending in three knobs
Cross crosslet: A cross with each limb crossed
Cross flory: A cross with each limb ending in a fleur-de-lis
Cross paty: A cross with the limbs splayed
Cross potent: A cross with crutch-shaped ends
Displayed: Describes an eagle with wings and legs outspread
Doubled: Lined
Enarched: Curved upwards
Enflamed: In flames
Eradicated: Uprooted
Erased: Torn off, leaving ragged edge
Escallop: Scallop-shell
(Of the) field: Same tincture as the field
Fitchy (or Fitché): Literally 'fixable' to the ground
Fleur-de-lis: Stylized lily flower
Garnished: Decorated
Gorged: Encircled round the neck or throat
Goutté (or Goutty) [d'or]: Scattered with drops [of gold]
Haurient: Describes a fish with head upwards as if taking in air
Impaling: The grouping of two coats of arms by dividing the shield palewise and placing the coat in each half
Jessant-de-lis: Having a fleur-de-lis 'throwing' forth
Langued and armed: Describes tinctures of tongue and claws
Leaved: Having leaves
Lymphad: Ancient galley
Mullet: Star-shaped figure usually of five points
Pheon: Barbed head of an arrow
Proper: In its natural colours
Quadrate: Squared
Rayonny (or Rayonné): Formed with rays
Seeded: Refers to the seed vessels of flowers
Segreant: Rampant, when applied to the griffin or dragon
Semé: Strewn or scattered with any charge
Slipped: Of a leaf, twig or flower when it has the stalk which attached it to the parent stem

LETTERING IN USE

I N this section there appears a selection of lettering work ranging from the familiar commissioned poem through graphic design and heraldry to letter-carving, engraving, signwriting and computerized type-design. Some contributors are not primarily calligraphers, some would not term themselves calligraphers at all; but they all share a knowledge of the edged pen as an essential part of what they do. Space is inevitably restricted but an attempt has been made to show some of the possibilities of calligraphy as a practical tool.

A final word. This book is dedicated to the notion that craftsmanship may be fully as important as 'art', and perhaps more so. In the case of calligraphy, it has been argued in recent years that in lending itself so readily to adaptation as an art form in the hands of a skilful few and attracting a large amateur following along the way, its future has become assured – it is 'alive and well'. This may not necessarily be the case. Much modern work is full of imagination, colour and flair but is noticeably short on the knowledge and understanding to be gained only from the sort of systematic training which virtually no longer exists. Calligraphy is certainly alive. Whether it is well is another matter.

RIGHT: *Greetings card design (not used). Flourished brush-lettered italic based on pen forms. The uncial 'E' forms provide a subtle decorative feature. (Ann Camp)*

GREETINGS
from Ealing
Technical College
&
School of Art

BELOW: *Projected title page for a light-hearted manuscript book. Built-up lightweight capitals accompanied by an informal pen-made script. (John Nash)*

LECTURE ON
As recited to the composer John Cage by a some-
JAPANESE
what drunken friend, late one night in Seattle
POETRY

The Wesley Study Centre

55 The Avenue · Durham · DH1 4EB · Telephone Durham (091) 386 · 1833
Director · The Reverend Christopher D. Wiltsher

NATIONAL
FILM FINANCE
CORPORATION
(1949-1985)

DINNER

Tuesday
17th December
1985

ABOVE: *Letterhead. Actual size. A medium-weight formal pen italic in two sizes employing a centred layout. The elegant springing of the arches in letters such as 'h', 'n' and 'r' should be noted. (Susan Hufton)*

LEFT: *Menu cover. Actual size. Another centred design using flourished pen-made italic capitals with a nice sense of forward movement, together with italic minuscules. (Lindsay Castell)*

OPPOSITE: *Book cover by Gaynor Goffe. Direct pen-made italic capitals with slightly built up terminations. The lateral compression of these capitals may be compared to the rounder versions in the previous example (Lindsay Castell). The title has been reversed out as part of the printing process to give white lettering on a textured green ground. (by permission of Golgonooza Press, Ipswich)*

OLD HAM
HALL

ABOVE AND BELOW: *Will Carter often describes himself as a jobbing printer, but he is also a particularly fine calligrapher and letter-carver. These two signs, both carved V-cut in wood have a strong calligraphic basis.*

OPPOSITE: *Endpaper for* Years of the Golden Cockerel: The Last Romanov Tsars 1814-1917 *(Macmillan, NY., 1968) This splendid map shows the versatility and great vitality of calligraphic lettering in map-making. Its flexibility ensures an effective blend with natural features and contours. Versals, roman and italic hands used together with great skill. (Joan Pilsbury)*

Zur Erinnerung an

FRIDEL MEYER

· Meisterschafts-Kanusportlerin ·

in Deutschland und England sehr verehrt

und durch ihren im Jahre 1933 neuen Rekord

im Kanu-Langstreckenwettbewerb rundum

Großbritannien weltberühmt geworden

✦

GEBOREN IN KITZINGEN AM MAIN 1908

GESTORBEN IN HARROGATE 1982

The Russia of the Last
Romanov Tsars
1814-1917

SCALE

Boundary of
Russian Empire

OTTOMAN EMPIRE

SEA OF OKHOTSK

SAKHALIN ISLAND

JAPAN

KOREA

Tsushima Straits

SEA OF JAPAN

Vladivostok

Port Arthur

Mukden

South Manchurian Railway

Harbin

Chinese Eastern Railway

MANCHURIA

AMUR PROVINCE

Amur R.

Shilka R.

CHINA

Lake Baikal

Siberian

Trans-

Tomsk

Tobolsk

Omsk

Ekaterinburg

SIBERIA

Urals

TURKESTAN

AFGHANISTAN

INDIA

PERSIA

Caspian Sea

Transcaucasia

Caucasus

Black Sea

Sevastopol

Crimea

Constantinople

Don

Volga

Moscow

ST. PETERSBURG

Kiev

Dnieper

FINLAND

Helsingfors

Baltic Provinces

SWEDEN

BARENTS SEA

GERMANY

POLAND

Warsaw

Vilna

Minsk

Mogilev

Baranovichi

Carpathians

AUSTRIA

Danube

RUMANIA

BULGARIA

Constantinople

Dardanelles

OTTOMAN EMPIRE

miles

AL-GHAZĀLĪ

THE REMEMBRANCE OF DEATH AND THE AFTERLIFE · *Kitāb dhikr al-mawt wa-mā baʿdahu* · BOOK XL of THE REVIVAL OF THE RELIGIOUS SCIENCES

Iḥyāʾ ʿulūm al-dīn · translated with an INTRODUCTION and NOTES by T.J.WINTER

Tom Perkins is a calligrapher, letter designer and letter-carver who has here employed drawn lettering to give a more typographic feel to the work.

WORLD ASSOCIATION FOR PUBLIC OPINION RESEARCH

CERTIFICATE ON THE CONFERRING OF

The Helen Dinnerman Award
1990

IT IS HEREBY CERTIFIED THAT

Elisabeth Noelle-Neumann Maier Leibnitz

has been awarded the Helen Dinnerman Award at the 1990 WAPOR-AAPOR Conference in Lancaster, Pennsylvania, USA, on the recommendation of a jury consisting of three former presidents of WAPOR: Robert Worcester, Seymour Martin Lipset and Hans Zetterberg.

This award is conferred in recognition of the contributions of Elisabeth Noelle-Neumann as a scholar, researcher, teacher, publicist, organizer, member and president of WAPOR (1979 - 1980) and as founder in 1947, of the Institut für Demoskopie, Allensbach.

She has combined in a unique way humanistic and theoretical learning and mainline empirical research and methodological innovations. Her linking of the empirical discovery with the history of social thought is an example for all of us. In her work she has made a point to speak rationally to important issues challenging the irrationalism in our time.

Innumerable questions formulated by her have been incorporated into research in many countries and into the European Values Study in which she so actively participated. She found original ways to phrase and present questions that have advanced our knowledge about politics, religion, the role of women, generational conflict, mass media behaviour, economic behaviour, the meaning of work and psychological well being.

Her work over decades has fulfilled more than anyone else the injunction of Paul Lazarsfeld "On the obligations of the 1950 pollster to the 1984 historian".

The spirited exchange with Bürkhard Strümpel "Does Work Make Sick, Does it Make Happy", showed her capacity to make survey research relevant to the problems of contemporary society. The same is true for her work on personality strength and physonomic expression for our understanding of human personality.

The discovery of the Schweigespirale (1980 and revised in 1989) the spiral of silence is already a classic and one of the most original contributions to the understanding of the dynamics of public opinion formation. As editor and author of the Lexikon für Publizistik, she provided a clear overview of the expanding range of this new discipline.

Her emphasis on continuity in research - and this from someone who is always innovating - makes her work invaluable for the student of social change and for future historians.

As a teacher of the Freie Universität Berlin, the University of Mainz and its Institut für Publizistik founded by her, as Georges Lurcy visiting professor at the University of Chicago & through collaboration with younger scholars she trained a brilliant cohort of researchers.

WAPOR is happy to join ESOMAR that awarded her in 1985 the prize for the best contribution to methodology, and the University of St Gallen that granted her an honorary degree in honouring the grande dame of our field, full of charm, always ready to play with new ideas and initiate new ways.

MAY 19, 1990
LANCASTER, PA, USA

ROBERT M WORCESTER
CHAIRMAN DINNERMAN
AWARD COMMITTEE

A classic design for a presentation address on vellum with differing weights and sizes of italic for the purpose of emphasis. (Patricia Gidney)

To S·A· by T·E·Lawrence

I LOVED YOU, so I drew
 these tides of men into my hands
 and wrote my will across
 the sky in stars
To earn you Freedom, the
 seven-pillared worthy house,
 that your eyes
 might be shining for me
 When we came.

Death seemed my servant
 on the road, till we were near
 and saw you waiting:
When you smiled, and
 in sorrowful envy he outran me
 and took you apart:
 Into his quietness.

Love, the way-weary,
 groped to your body, our brief wage
 ours for the moment
Before earth's soft hand
 explored your shape, and
 the blind worms grew fat upon
 Your substance.

Men prayed me that I set
 our work, the inviolate house,
 as a memory of you.
But for fit monument
 I shattered it unfinished: and now
The little things creep out
 to patch themselves hovels
 in the marred shadow
 Of your gift.

This plaque
was unveiled by
SIR PAUL GIROLAMI
Chairman of Glaxo Holdings plc
on the opening of the new
Pharmacy Building
on 12th October
1989

ABOVE: *Carved and gilded plaque in black Welsh slate. The*
V-cut lettering is based on pure calligraphic italic forms, but is
modified in an individualistic way by this extremely talented letter
designer. A centred layout with nicely restrained flourishes
to fill voids. (Tom Perkins)

OPPOSITE: *Poem from the beginning of T.E. Lawrence's*
Seven Pillars of Wisdom. An elegant formal italic entirely
suited to the text. The layout is left-justified and each verse starts
with a small versal capital, the last line being slightly
indented. (Edward Wates)

MAKING·RUBBINGS
YOURSELF
IS·FUN
AND·COSTS·VERY
LITTLE:MATERIALS
AVAILABLE·AT·THE
CAMBRIDGE·BRASS
RUBBING·CENTRE:

FREE·TUITION·MEANS
GOOD·RESULTS
FIRST·TIME

ABOVE: *Device for a booklet cover engraved in wood (courtesy of Harriet Frazer). Traditional italicized roman capitals and italic minuscules with refined flourishes, by a trained wood engraver. (Michael Renton)*

No Parking

ABOVE: *The London workshop of William Sharpington produced, from the 40s to the 60s, some of the most distinguished public lettering in England. This straight-forward and well-spaced example of roman minuscule, once at the entrance to a North London park, has since disappeared.*

OPPOSITE: *An outdoor sign, silk screen printed in gold ink on black perspex. Pen-made Roman capitals varying in size for the sake of the emphasis and, overall, a tight inter-line spacing pattern to give a densely textured effect. (Gerald Fleuss)*

HK

In celebration
of an event which took place
on Thursday 13th July 1950
for which they have
reason to be grateful,
John, Gillian, Richard & Gill Prew
beg to be allowed to enjoin

Kathleen · née Ambler
and Harry Prew

to dine together
at the
Dovecliff Hall Hotel · Stretton
on Saturday 21st July 1990
at 8·15 pm,
and to join them there
for lunch on the morrow,

of which may this serve
for many more happy years
as a reminder.

RUBY

*Ruby Wedding Celebration invitation written out with goose and
swan quills on BFK Rives printmaking paper. A lively italic hand
in varying sizes with some delightfully vigorous flourishes.
(Richard Middleton)*

NATIONAL ASSOCIATION OF HEALTH STORES

Diploma in Health Food Retailing

This is to certify that

has attained the standard
set in the final examination by the
Examiners and the N·A·H·S· Education
and Training Board and is hereby awarded
the National Association of
Health Stores Diploma in
Health Food Retailing.

Signed on behalf of the Examiners NAHS Training School
PRINCIPAL

Signed on behalf of the NAHS Education and Training Board
CHAIRMAN SECRETARY

*A diploma design in italic by a leading calligrapher who also happens
to be left-handed. The elegant letter forms are more laterally-
compressed than usual giving them a rich, almost gothic effect. The
logo design is obviously calligraphically oriented and forms a perfect
complement to the script. (David Williams)*

TO
THE MEMORY
OF
DAVID CARRITT
1927-1982
from
His family & friends
Artemis
Sir Alfred & Lady Beit
The Viscount Camrose
Dr. Christian Carritt
Christie's
The Honourable
Lady Hastings
Heather & David Hilliard
Elizabeth Hilliard
Baron Lambert
Robert M. Light
Christopher Loyd
The Honourable
Mr & Mrs Christopher McLaren
Clare & Eugene Victor Thaw
The Lady Vestey

*Brush-lettered inscription showing vigorous italic and mastery
of flourishing by a lettering craftsman equally skilled with the
broad pen. (Kenneth Breese)*

The heavens,
the earth
the sea,
AND ALL THAT
IS IN THEM
praise the
Author of
your coming
AND THEY
SING A SONG
of Joy

*Greetings card design by a highly-skilled calligrapher who is
also left-handed. The lively italic with its wonderfully
controlled flourishes is punctuated with two blocks of small
Roman capitals in a reversal of the usual hierarchy of scripts.
(Gaynor Goffe)*

The arms illustrated
are those of Lord Montagu's
father, differenced by
a gimmel ring, with an
Escution of Pretence of
the arms of his wife,
Isabel, daughter and
heir of sir Edmund
Ingoldsthorpe, of
Borough Green,
County Cambridge.

Sir John Nevill Lord Montagu

Blazon:—
The following blazon is of
Lord Montagu's achievement
of Arms as displayed on his
stall Plate, at St George's
Chapel Windsor
Castle.

Sir John Nevill was the third son
of Richard Nevill, Earl of Salisbury
and Alice, only daughter of Thomas
de Montacute, Earl of Salisbury,
Lord Montacute and Monthermer
and Count of Perche; and suo jure
Countess of Salisbury. He was
knighted in 1449 and was attainted
and restored with his father
in 1460. In 1461 he was made
a Privy Councillor and Lord
Chamberlain of the Household
and was summoned to Parliament
as Lord Montagu. In March
1461-2 he was created a Knight
of the Garter and from 1463–1470
filled the post of Warden of
the East Marches. In 1464 or 1465
he was created Earl of
Northumberland but in 8 Edward IV
the creation was cancelled and
in 1470 he was made Marquess of
Montagu. He was killed at the
Battle of Barnet in 1471.

KNIGHT OF THE ORDER OF THE GARTER 1461/2 – 1471

Arms:—
Quarterly, FIRST AND FOURTH
Argent, three fusils in fess gules,
(for Montacute) Quartering
Or, an eagle vert the beak and legs
gules, (for Monthermer)
SECOND AND THIRD: gules
a saltire argent and a label
gobonny of argent and azure
(for Nevill). With an ESCUTION
OF PRETENCE — Quarterly:
1 Argent, A quarter gules (for
a rose or in the quarter. (for
Bradstone) 2. Gules, a cross
engrailed argent (for Ingoldsthorpe).
3 Azure, a fess and three leopards
heads or and on the fess a ring
azure for difference (for De
La Pole). 4. Argent, a dance sable
and three bezants on the dance.
(for De Burgh)
In the upper part of the shield
there is a gimmel ring argent
and azure for difference.

Crest:— sitting on a
jewelled crown or, a griffin with
wings displayed or, and
a gimmel ring argent and
azure in its beak for difference.

Mantling:— Gules,
lined ermine:— and sown
with large pointed leaves.

This panel was designed,
written, painted and gilded
by Dru Brown, July, 1988.

ABOVE: *Design for a presentation award where the client requested something slightly out of the ordinary, hence the use of a much-flourished italic in white gouache on a black Arches MBM paper. The logo is in a greyish green italic with white capitals. (Gerald Fleuss)*

RIGHT: *Headstone with lettering 'V' cut in Cumbrian green slate. Traditional 'Trajan' type Roman capitals and pen-derived italic minuscules in a generously spaced centred layout. The device at the top is also pen-inspired. (John Nash)*

OPPOSITE: *Arms of Sir John Nevill. Differing sizes of italic are employed in this unusual layout, with the heading in a more compressed and angular version to give a strong medieval flavour to the work, whilst remaining entirely contemporary. The heraldry is freely based on medieval Garter stall plates in St. George's Chapel, Windsor Castle (see Fig. 1 Heraldry chapter). (Denis Brown)*

An invitation to Dorking from

LEFT: *Cover of leaflet folded to one third A4 size. Bold roman minuscules with bracketed and slab serifs, nicely contrasted in two sizes. The logo design (from an idea by John Lang) employs Roman capitals on a scroll. (John Woodcock)*

RIGHT: *Information leaflet. A bold italic script with a cursive quality imparted by the use of strong ligatures. (John Woodcock)*

HAMLET'S
MILL

*An Essay
Investigating the Origins of
Human Knowledge, and its
Transmission through Myth*

HAND
MADE
PÆPER

Journal of the

*American Musical
Instrument Society*

AMIS

VOLUME I · 1975

*Three examples of calligraphic work
for reproduction by a distinguished
letter designer formerly associated
with the Stinehour Press of
Lunenburg, Vermont, U.S.A.
(Stephen Harvard)*

John Benson (of the John Stevens Shop in Newport, Rhode Island), equally skilled with pen, brush and chisel, has recently extended his preoccupations to the field of computerized type design, using a Macintosh. The following are examples of preliminary work on two experimental type faces, showing the outstandingly lively and consistent quality obtainable when the basic letter forms are not drawn as separate shapes but arise naturally from a sequence of inter-related direct pen forms done by an expert hand. Here the computer is used properly as a tool to reduce drudgery, rather than as a substitute for knowledge and judgement.

FIRST: *an adaptation of a fairly formal, serifed "roman" minuscule:*

Pen-made original, same size

I am always looking forward to some to some event; when I finish this,

Pen-made original, enlarged

I am always looking forward to some event; when I finish

First draft of computer-generated bitmap version – two sizes

swim away from me do ye murmered ahab gazing over into the water. there seemed but

swim away from me gazing over into the

sphinx of black quartz judge my vow

Pen-made original

Image as seen on computer screen

Three subsequent stages, during which the letters are progressively refined, but great care is taken to preserve the unity and rhythm of the whole

judge my

Scanned image

judge my

Edited bitmap font

judge my

Postscript font

SELECTIVE BIBLIOGRAPHY

Manuals on calligraphy and pen lettering

Benson, John Howard, and Carey, Arthur Graham: *The Elements of Lettering* (John Stevens, Newport, R.I., 1940). Still the most authoritative and thoughtful book of its kind to come out of the USA.

Biggs, John R.: *Lettercraft* (Blandford Press, 1982). Incorporates three previous books, one on lettering in general, one on pen lettering in particular (some of which needs to be taken with a pinch of salt) and one on copperplate script.

Camp, Ann: *Pen Lettering* – (latest edition A. & C. Black, 1984). Remains the best short introduction to the subject.

Child, Heather (ed.): *The Calligrapher's Handbook* (A. & C. Black, 1985). An updating of the previous *Calligrapher's Handbook* edited by C. M. Lamb; contains definitive articles on (among others) paper and preparation of quills and vellum. Not to be confused with a vastly inferior publication of the same name published at about the same time.

Fairbank, Alfred: *A Handwriting Manual* (Faber & Faber, 1954) and *A Book of Scripts* (Faber & Faber, 1977). Essential for students of italic.

Gardner, William: *Alphabet at Work* (A. & C. Black, 1982). An introduction to pen lettering which goes on to relate it to applied lettering of various kinds in a way too seldom done.

Gourdie, Tom: *The Puffin Book of Lettering* (Penguin Books, 1961) and *Calligraphy for the Beginner* (A. & C. Black, 1983). Both are models of clarity and brevity and, like Gourdie's other books, are written out in his own incredibly disciplined italic hand – a model in itself.

Haines, Susanne (ed.): *The Calligrapher's Project Book* (Collins, 1987).

Halliday, Peter (ed.): *Calligraphy Masterclass* (Collins, 1990).

Harvey, Michael: *Lettering Design* (Bodley Head, 1975). A swift, comprehensive survey of letters and their use by a leading English lettering craftsman. Of his three subsequent shorter books the most valuable is perhaps *Carving Letters in Stone and Wood* (Bodley Head, 1987).

Hewitt, Graily: *Lettering* (Frederick Warne, 1930; Taplinger, New York, 1981). A useful and thorough manual, somewhat unfairly eclipsed by Johnston's book and deserving to be better known.

Johnston, Edward: *Writing and Illuminating, and Lettering* (first published by John Hogg, London, 1906; then by Pitman & Sons, and most recently A. & C. Black in London and Taplinger in New York). Many of the models are now outdated, but the insights which produced them are as relevant as ever; the text can be returned to again and again. Two other collections of Johnston's writings have appeared: *Formal Penmanship* (ed. Heather Child, Pentalic, New York, 1971) and *Lessons in Formal Writing* (ed. Heather Child and Justin Howes, Lund Humphries, London, 1986).

Laker, Russell: *Anatomy of Lettering* (Studio Publications, 1946). Designed for commercial letterers rather than calligraphers, and none the worse for that. Much useful, if somewhat dated, information.

Mahoney, Dorothy: *The Craft of Calligraphy* (Pelham Books, 1981). That the author was an assistant and disciple of Johnston is evident in some of the over-imitative details; it contains a wealth of good examples, however, not least the author's own beautiful and vigorous italic.

Martin, Judy: *The Complete Guide to Calligraphy* (Phaidon Press, 1987). The word 'complete' in the title, like 'easy' or 'creative', is usually a very bad sign; this book has no bibliography, which is another. Contains some useful information.

Peace, David: *Glass Engraving: Lettering and Design* (B. T. Batsford, 1985). This book provides the most complete examination to date of lettering

applied to glass, and also includes original research into Eric Gill's lettering work.

Svaren, Jacqueline: *Written Letters: 22 Alphabets for Calligraphers* (The Bond Wheelwright Company, Freeport, Maine, 1975). Full of useful tips and American enthusiasm; its saving grace lies in the introductory warning that the alphabets presented are the author's 'interpretations'.

Palaeography and history

Atkins, Kathryn A.: *Masters of the Italic Letter* (The Penguin Press, 1988). A beautifully produced book containing short descriptions of, and illustrations from, twenty-two 16th-century writing manuals, with a most interesting 'Letter Study' section.

Benson, John Howard: *The First Writing Book: Arrighi's Operina* (Yale University Press, 1954). Benson not only translated Arrighi's manual but wrote it out in appropriate chancery cursive, conforming to the original layout; a most useful *tour de force*.

Bischoff, Bernhard: *Latin Palaeography* (trans. Dáibhí O'Cróinín and David Ganz, Cambridge University Press, 1990). New translation of a classic; full and updated bibliography.

Bishop, T. M.: *English Caroline Minuscule* (Cambridge University Press, 1971).

Catich, Father Edward: *The Origin of the Serif* (1968) and *The Trajan Inscription in Rome* (1961), (both published by the Catfish Press, Davenport, Iowa). The first is an increasingly influential defence of Catich's theories concerning the brush-influenced sources of the Trajan letter forms; the second is an immensely useful portfolio of drawings and photographs taken directly from the inscription by Catich himself.

Evetts, L. C.: *Roman Lettering* (Pitman & Sons, 1938). An examination of the letters of the Trajan inscription, over-dependent on geometrical construction but still full of valuable insights.

Goudy, Frederic W.: *The Alphabet* (Mitchell Kennerley, New York, 1918). The prolific American type designer's handbook of lettering, showing the importance he gave to the pen; still surprisingly relevant.

Gray, Nicolete: *A History of Lettering* (Phaidon Press, 1986). A useful general history; otherwise valuable as a source of highly individual historical examples and some controversial ideas. Good bibliography.

Harvard, Stephen: *An Italic Copybook: The Cataneo Manuscript* (Taplinger, New York, 1981). A careful and illuminating examination of a very rare commodity – a written (not printed) copybook by a Renaissance writing master, printed in facsimile by the Stinehour Press. Again, a must for any serious student of italic.

Jackson, Donald: *The Story of Writing* (Studio Vista, 1981). Useful for descriptions of medieval techniques.

Knight, Stan: *Historical Scripts* (A. & C. Black, 1984). Examples and descriptions of historical scripts carefully chosen with the calligrapher in mind; an authoritative and essential handbook.

Lowe, E. A.: *English Uncial* (Oxford University Press, 1960); *Codices Latini Antiquiores* (Oxford, 1934–66).

Morison, Stanley: *Politics and Script* (Clarendon Press, 1972). Not everyone agrees with the author's conclusions, but they cannot be dismissed. It needs to be read and re-read.

Nesbitt, Alexander: *The History and Technique of Lettering* (Dover Publications, 1957). An awe-inspiring attempt (and a remarkably successful one) to give a complete account of various historical scripts from their beginnings right through to their translation into typefaces, and on to the commercial lettering of the present day.

Ogg, Oscar: *Three Classics of Italian Calligraphy* (Dover Publications, 1953). Again, principally for students of italic – unadorned facsimiles of the writing books of Arrighi, Tagliente and Palatino, with a careful bibliography by A. F. Johnson and considerable help from James Wardrop. Ogg also produced *The 26 Letters* (Geo. T. Harrap, 1949), a history of lettering for the general reader, very engagingly done, and *Lettering as a Book Art* (George McKibbin & Son, New York, 1949).

Osley, A. S.: *Scribes and Sources* (Faber & Faber). The book to read to know the background not merely of the Renaissance writing masters' books, but of the men themselves; scholarly writing of real wit and grace, only to be surpassed, in this field, by Wardrop.

Thompson, Sir Edward Maunde: *An Introduction to Greek and Latin Palaeography* (Clarendon Press, 1912). Hard to find, but invaluable so long as your interests don't lie beyond the close of the 15th century. An exhaustive bibliography.

Ullman, B. L.: *Ancient Writing and its Influence* (Longmans, Green & Co., New York, 1932). Brief

and early, but still referred to when longer works have been forgotten. For Renaissance enthusiasts, a later work is crucial: *The Origin and Development of Humanistic Script* (Edizioni di Storia e Litteratura, Rome, 1960).

Wardrop, James: *The Script of Humanism* (Clarendon Press, 1963). Remains the best written and most informative account of those Renaissance scribes whose work remains in manuscript rather than in printed form; to be read and enjoyed even if your principal interest does not lie with italic writing.

Lettering collections and source books

Brinkley, John (ed.): *Lettering Today* (Studio Vista, 1964). Contains an excellent calligraphy section edited by Sheila Waters, and a section on architectural lettering by Ken Garland which still astounds by its ignorance.

Carter, Will: *Carter's Caps* (Rampant Lions Press, 1982). An alphabet of Roman capitals designed and cut in wood by Carter, with illuminating commentary.

Child, Heather, (ed.): *Calligraphy Today* (A. & C. Black, 1988).

Degering, Hermann: *Lettering* (Ernest Benn, 1929).

Hermann Zapf and his Design Philosophy (Society of Typographic Arts, Chicago, 1987). Survey of the career and calligraphic background of one of today's most influential letterers and typographical designers.

Lettering of Today (Studio Ltd., 1957).

Lindegren, Erik: *An ABC-Book* (Pentalic Corporation, 1976). A compilation of three previous books, the final one on typography. A good showcase for letterers from several countries. Seventeen pages are taken up with a facsimile and translation of Arrighi's *Operina*, seen to better and more useful advantage in John H. Benson's edition, listed above.

Modern Lettering and Calligraphy (Studio Ltd., 1954).

Modern Scribes and Lettering Artists (vol. 1: Studio Vista, 1980; vol 2: Trefoil Books, 1986).

More Than Fine Writing: Irene Wellington: Calligrapher (1904–1984) (Heather Child, Heather Collins, Ann Hechle, Donald Jackson, Pelham Books, 1986). Irene Wellington was probably the most influential and original of Johnston's pupils, and the development of her work is marvellously set forth in this compilation, in which carefully chosen reproductions wisely take first place.

Tschichold, Jan: *Treasury of Alphabets and Lettering* (Omega Books, 1985). This recent reissue in translation of the Swiss type designer's *Meisterbuch der Schrift* would be worth having solely for the sake of the marvellous demolition job on 'self-expressive' lettering set forth in the introduction; but it also has carefully chosen facsimiles (most, it must be said, of typefaces rather than lettering).

Two Thousand Years of Calligraphy (Walters Art Gallery, Baltimore, Maryland, 1965; Taplinger Publishing Co., 1980). Catalogue of a three-part exhibition whose modern calligraphy section is still an invaluable comprehensive survey and source of biographical detail.

Heraldry

Boutell, Charles (revised J. P. Brooke-Little): *Boutell's Heraldry* (first published 1863; latest edition Frederick Warne & Co., 1983).

Child, Heather: *Heraldic Design* (G. Bell & Sons, 1965).

Fox-Davies, A. C.: *The Art of Heraldry* (first published 1904; reprinted Bloomsbury Books, 1986).

Fox-Davies, A. C. (revised J. P. Brooke-Little): *A Complete Guide to Heraldry* (first published 1909; latest edition Thomas Nelson & Sons, 1983).

Friar, Stephen (ed.): *A New Dictionary of Heraldry* (Alphabooks, 1987).

Neubecker, Ottfried: *Heraldry, Sources, Symbols and Meaning* (Macdonald & Jane's, 1976).

St. John Hope, W. H.: *Heraldry for Craftsmen and Designers* (Pitman & Sons, 1913).

Volborth, C. A. von: *The Art of Heraldry* (Blandford Press, 1987).

Woodcock, Thomas, and Robinson, John Martin: *The Oxford Guide to Heraldry* (Oxford University Press, 1988).